ANF 778
3332700
Beglei
50 ligh
portra.

VOLUME TWO

50

LIGHTING SETUPS

FOR PORTRAIT PHOTOGRAPHERS

*Easy-to-follow lighting
designs and diagrams*

Steven H. Begleiter

AMHERST MEDIA, INC. ■ BUFFALO, NY

MOOSE JAW PUBLIC LIBRARY

DEDICATION

I would like to dedicate this book to my wife, Kate, and to our two children, Makhesh and Metika, for their support and understanding.

Copyright © 2012 by Steven Begleiter.
All rights reserved.
All photographs by the author.

Published by:
Amherst Media, Inc.
P.O. Box 586
Buffalo, N.Y. 14226
Fax: 716-874-4508
www.AmherstMedia.com

Publisher: Craig Alesse
Senior Editor/Production Manager: Michelle Perkins
Assistant Editor: Barbara A. Lynch-Johnt
Editorial Assistance from: Carey A. Miller, Sally Jarzab, John S. Loder
Business Manager: Adam Richards
Marketing, Sales, and Promotion Manager: Kate Neaverth
Warehouse and Fulfillment Manager: Roger Singo

ISBN-13: 978-1-60895-487-2
Library of Congress Control Number: 2011942804
Printed in The United States of America.
10 9 8 7 6 5 4 3 2 1

No part of this publication may be reproduced, stored, or transmitted in any form or by any means, electronic, mechanical, photocopied, recorded or otherwise, without prior written consent from the publisher.

Notice of Disclaimer: The information contained in this book is based on the author's experience and opinions. The author and publisher will not be held liable for the use or misuse of the information in this book.

Check out Amherst Media's blogs at: http://portrait-photographer.blogspot.com/
http://weddingphotographer-amherstmedia.blogspot.com/

Table of Contents

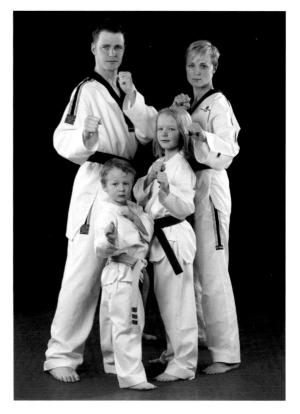

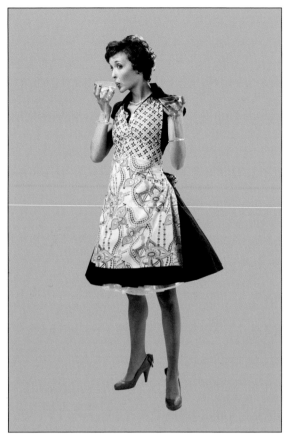

ABOUT THE AUTHOR

Steven H. Begleiter is a freelance photographer living in Missoula, Montana. Before moving to Missoula, he was a lecturer of photography at the University of Pennsylvania School of Design. He has authored four books: *Fathers and Sons, The Art of Color Infrared Photography, The Portrait Book: A Guide for Photographers,* and *50 Lighting Setups for Portrait Photographers*—the companion volume to this book. He is also a contributor to trade magazines such as *Photo Techniques* and *Rangefinder,* and has been featured in *Studio Photography.*

His professional career began in 1980 as first photo assistant to Annie Leibovitz and Mary Ellen Mark. Since then, his work has appeared in *Esquire, Big Sky Journal, Us Magazine, Forbes, Elle, Business Week,* on the cover of *Time,* in Fortune 500 annual reports, and in national advertising campaigns.

He is a recipient of a Greater Philadelphia Cultural Association grant and has served on the board of the Philadelphia Chapter of the American Society of Media Photographers.

Begleiter has also taught at the Rocky Mountain School of Photography and currently runs a freelance photography business based in Missoula, MT. For more information: www.begleiter.com

ACKNOWLEDGEMENTS

Over the years since my last book was published there have been many people to thank for keeping my dream alive. I can divide them into two categories:

Those who assisted me with my work: I would like to thank Beth Costigan and Christy Tatsey who assisted me on many of the shoots that appear in the book. I would also like to thank two of my favorite makeup and hair people, Meg Hanson and Katie Murphy, who transformed many of my female clients into sirens.

Those who hired me: Thanks to all the clients who kept my engine running—especially Bob Caldwald and Dana Hillyar, Steve Robertson, Rory Burmeister, Neesha Johnson, Mat King, Marlene Hutchens, and Robert and Tina of Studio Beppa, Ltd., who consistently support my vision and work.

Lastly, I would like to dedicate this book to the memory of John Siegrist, a great guy who is sorely missed.

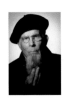

CASE STUDY 1

Portrait of an Artist

ASSIGNMENT

I wanted to create a Fourth of July promotion for my studio spe-cials—and a local artist, Charles Martin, wanted to have charac-ter photos of him taken of him for his modeling portfolio. After talking about our objectives, we went to work.

VISUAL OBJECTIVE

The ultimate goal of this session was to create a colorful image of Uncle Sam (see case study 2). However, as in all good portrait sessions, we kept an open mind to alternatives which resulted in this "portrait of an artist" photo—a different look for his portfolio.

POSING AND LIGHTING

In this photograph, we started out playful. But thinking about the shape of the hat, and looking at his hands and angular

STAY FLUID

Stay fluid with your lighting setups. The first two case studies in this book are good examples of being aware of the intention of the photo-graph. If I had used the same lighting setup for the "por-trait of an artist" photo as I did for "Uncle Sam" (see page 9), the images would not have had the same impact. Lighting creates the "feel" of portrait and the right lighting can strengthen the message you are trying to convey to the viewer.

CAMERA DATA

Camera: Canon 40D
Aperture: f/9
Lens: EF 24–105mm at 96mm
Shutter speed: $1/100$ second
ISO: 100

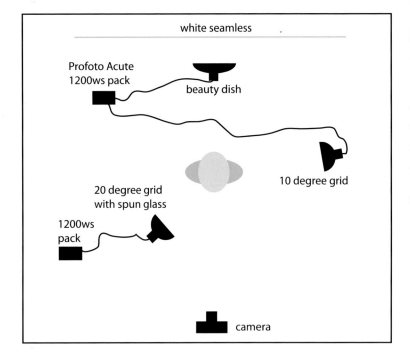

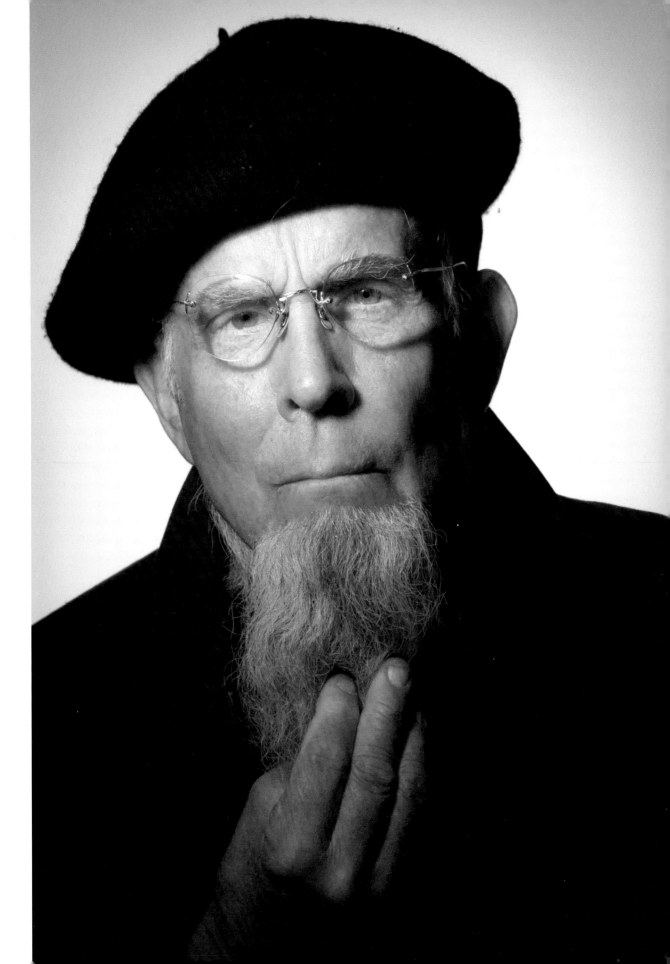

face, I decided to change my initial Paramount lighting setup and lose the fill light for a more dramatic look. I switched from a 40 degree grid to a 20 degree grid and raised the main light to about two feet above my subject's head. I added a sheet of spun glass over the grid to diffuse the light and added a piece of black gaffer's tape in the center of the grid. I also added a hair light with a 10 degree grid to place a highlight on his ear. I felt this little shaft of light on his ear balanced the weight of the photo.

EDITING PROCESS

After the shoot, I uploaded my images to Adobe Lightroom. I assigned keywords to the images (subject's name, studio shoot, Uncle Sam, etc.) and downloaded them onto an external hard drive for backup. After making some basic image selections (using the letter P for pick), I re-edited using the star system (the more stars the better) to narrow the images down to my favorites. I exported these to a DVD, labeled with the date and subject, and placed the DVD in the sleeve of a notebook.

POSTPRODUCTION

This particular image was converted to black & white—with some manipulations using the color slider in Lightroom's black & white module. My final settings were: +9 red; –35 orange; +18 green; + 49 aqua; –79 blue; –64 purple; and –5 magenta. I then went into the detail module and sharpened the image to 71 with a radius of 1 and a detail setting of 50. The final step was to create a vignette and add some grain. I moved down to the effects module and set the post-crop vignetting amount to –39, the midpoint to 44, and the roundness to –39. I feathered it to 50. Then I went into the grain section and adjusted the amount to 14, the

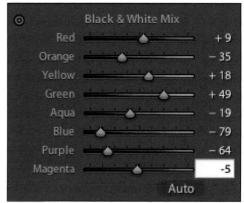
Converting to black & white in Lightroom.

Sharpening in Lightroom.

Adding a vignette in Lightroom.

Adding grain in Lightroom.

size to 11, and the roughness to 5. Since I was only doing global changes, not local ones, I did not have to export the image into Adobe Photoshop.

Uncle Sam

ASSIGNMENT

This is the image I created with Charles for my studio's Fourth of July promotion. He brought in the wardrobe and I provided a copy of the original poster for reference.

VISUAL OBJECTIVE

I wanted to bring out the illustrative quality of the poster with my lighting but also give the presentation a more contemporary look by replacing the original artwork with a photograph.

POSING AND LIGHTING

In this photograph, I was trying to replicate the pose in the original poster. I knew I would need a good depth of field to keep both the hand and the face into focus.

I also wanted to use a medium focal length, a little on the wide side, in order to avoid distorting the hand too much. I had the model look at the poster to get an idea of the expression and directed him to look "through" the camera lens.

I wanted to replicate the look of a bright sunny day, since I planned to drop in a sky background in postproduction. Knowing this, I first set up my main light and used this to establish the required settings for the rest of the lights. The main light was set to f/16, so I could get the depth of field required. This meant I had to set my kicker lights and hair light at f/22 (one stop brighter) to simulate backlighting. I placed a grid and a warming gel (1 CTO) on the hair light to re-create the look of late-day sun.

POSTPRODUCTION TECHNIQUE

After the shoot I uploaded, edited, and archived my images in Adobe Lightroom (as described in case study 1). Once the files were all backed up and safe, I selected the final image and brought out the red and blue colors using the color module in Lightroom. I also increased the saturation a little on each color.

HAVE A PLAN

With the vast assortment of tools we photographers have at hand, it's important to have a plan in place before beginning to shoot. For instance, in this shot I knew I was going to digitally drop in a background—so shooting on white made it a lot easier.

CAMERA DATA

Camera: Canon 40D
Aperture: f/16
Lens: EF 24–105mm at 28mm
Shutter speed: $^1/_{200}$ second
ISO: 100

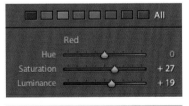

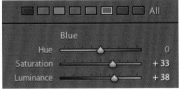

Enhancing the reds and blues in Lightroom.

I then sharpened the image to create a more vivid look and exported the image into Photoshop.

In Photoshop, I duplicated the background layer and selected the white background with the magic wand set at 50. (*Note:* Once I've made a selection I always save it by going to Select>Save Selection. If I should accidentally close the file or deactivate the selection, this lets me bring it right back by going to Select>Load Selection.) Then, I went back into Lightroom and entered "sky" in the grid module search to bring up all my "elements" images. (I'm always adding textures and images of generic objects to this collection of photographs.) I found a good vertical sky shot and exported it into Photoshop. I made sure both images were the same size, the same bit depth (usually 16), and that they had the same color profile (usually sRGB).

I copied and pasted the sky element into the Uncle Sam image, dropping it in behind the subject. Then I selected the Uncle Sam layer and reloaded the selection. Finally, I erased the white area around my subject to reveal the sky layer behind him.

Saving the active selection.

The Save Selection dialog box.

Retrieving a saved selection from the Load Selection dialog box.

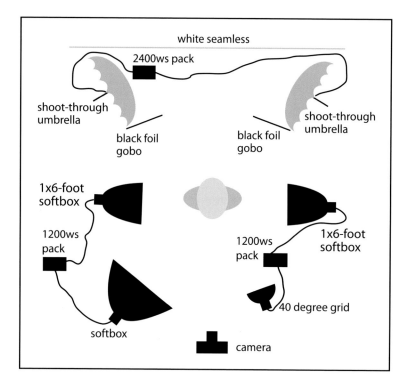

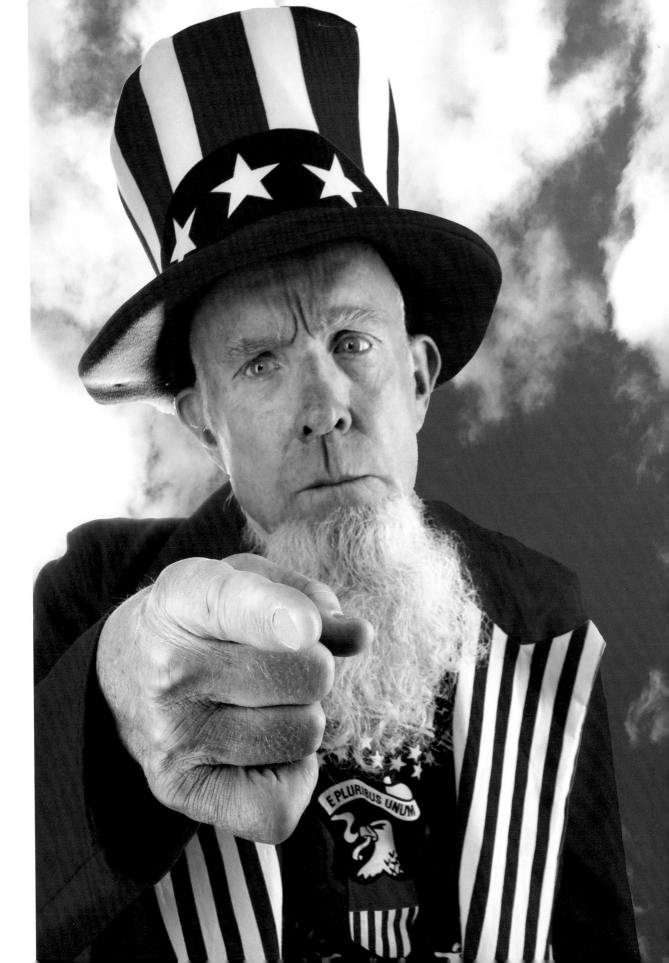

CASE STUDY 3

Julie Cajune

ASSIGNMENT

An art director who saw my work on the web contacted me to photograph Julie Cajune for a journalism magazine called *Miller-McCune*. Ms Cajune was being profiled for her work with the Native American Salish tribe in Arlee, Montana.

VISUAL OBJECTIVE

Editorial assignments are always my favorite type of job. Aside from my personal work, they typically give me the greatest degree of visual freedom—and I usually meet some very interesting people during the shoots. Ms. Cajune was no exception. When doing editorial work, I always request a copy of the publication's story to read before the shoot, so that I can gain a better understanding of why I am being assigned to photograph the person and begin to pre-visualize how I want to photograph the subject.

Knowing that this was a feature article—and hoping the shot might be chosen for the cover (sadly, it wasn't)—I decided to design a strong vertical image to open the story. I scouted for a good backdrop that yelled "mountains and nature."

POSING AND LIGHTING

Like a cinematographer framing the shot, I use my index fingers and thumbs to box the frame. I always prefer to scout and set up the frame before my subject arrives. Once I had my frame, I set up my lighting, having my assistant sit in as I adjusted each light source.

I began by measuring the ambient light at 100 ISO and based my strobe lighting on that ambient f-stop. In this case, I knew that at $^1/_{125}$ second the ambient overcast lighting was at f/8, so I set up my main light with a softbox to the right of my camera and powered up the strobe (Profoto 1200) to illuminate my subject at f/8.5. I then placed my Hensel 1200 Porty pack behind the bushes and directed a light at her back to separate

KNOW THY SUBJECT

When shooting editorial photography, do not give the editor too much to choose from—especially images you don't like (they will run them!). I have found that the more research I can do before I meet my subject, the more successful the shoot will be. I suppose one of the photographer's ten commandments would be "know thy subject."

CAMERA DATA

Camera: Canon 40D
Aperture: f/8
Lens: EF 24–105mm at 105mm
Shutter speed: $^1/_{125}$ second
ISO: 100

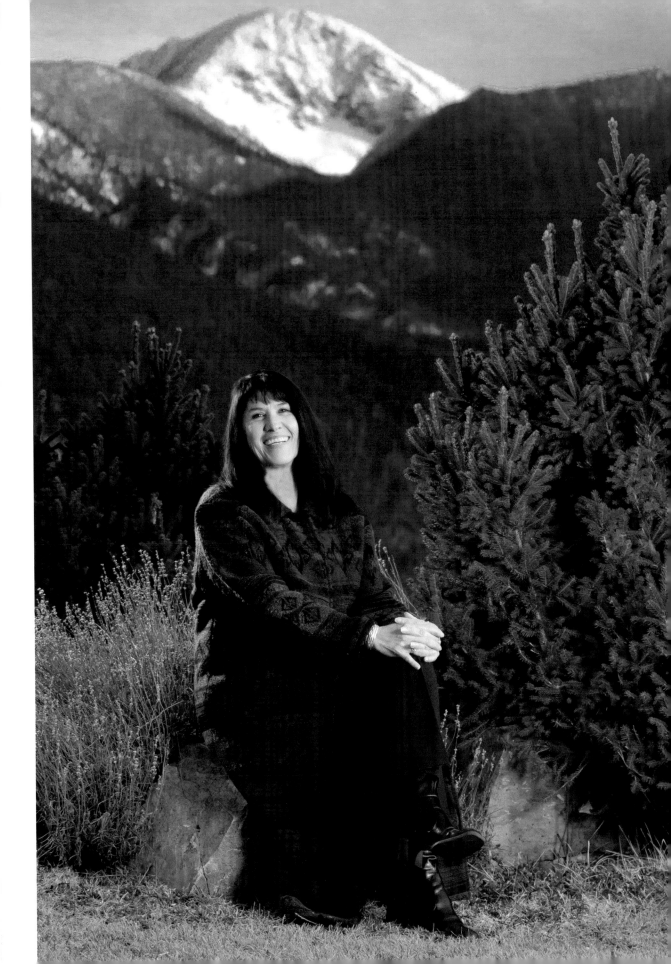

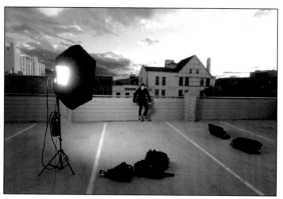

Working with Nate on the rooftop.

Deepening the sky color in Lightroom.

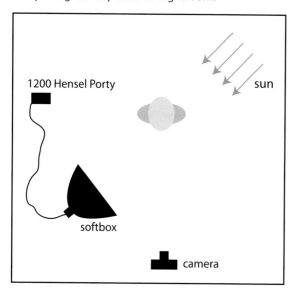

POSTPRODUCTION AND PROOFING

After the shoot I uploaded my images to Adobe Lightroom, then edited and archived them as described on pages 6–8.

Once the files were backed up and safe, I selected the final image and brought out the sky using the color module in Lightroom (remember not to go too far with the sliders; the result could create clipping). I then sharpened the image to create a more vivid look.

Next, I moved all the selected images into Lightroom's web module and created a web gallery for my client. I then exported the images onto my desktop, color-labeling the folder red so I could find it to "compress" on the Mac.

Using the FTP feature on Livebooks (an editable web site for photographers), I downloaded the compressed folder of Nate's images. This created a web site link that I could send to my client to review and select images from. This proofing method works very well with my digital workflow and is relatively easy.

Once Nate and his family picked their favorites, I moved the chosen images into Photoshop and did very basic retouching. For this image, I simply got rid of a telephone wire (using the spot healing brush) and some blemishes (using the patch tool). I also used the dodge tool to lighten the eyes and the shadow side of the face. Since I was sending the files out to be printed, I converted the files to the JPEG format and exported them to the White House Custom Color (WHCC) "to print" folder on my desktop.

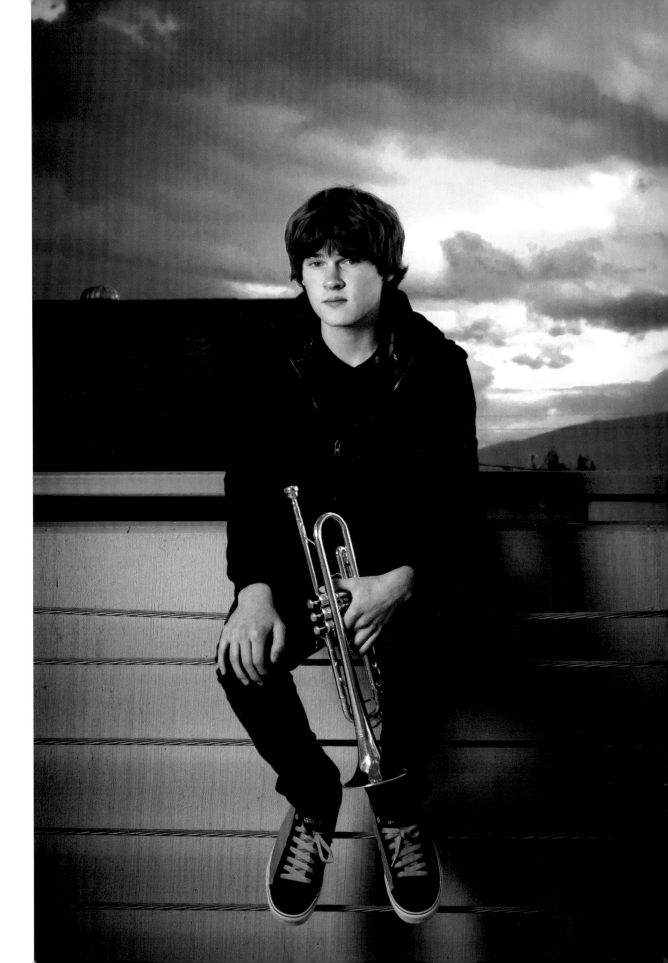

CASE STUDY 5

Nate in the Studio

ASSIGNMENT

As I mentioned in the previous case study, most seniors prefer outdoor shots. However, to distinguish myself from other senior portrait photographers in town I offer a studio shot as an alternative. In fact, I usually start out the session in the studio so the senior feels more comfortable about having his portrait taken outside, where there is less control. This session was an exception; we did the outside shot first because the shoot was scheduled late in the day and I wanted to be sure I had time to work before the sun set. Then, we moved into the studio.

VISUAL OBJECTIVE

I wanted to capture Nate's whimsical nature. He was a very conceptual person who also happens to be tall, thin, and flexible. I chose a black background to isolate his appearance (plus, black is cool). Then, of course, there were the shoes.

POSING AND LIGHTING

After trying some standing poses I got the idea of having Nate sit cross-legged on a posing chair (a round seat that spins). He obliged and looked very comfortable in that position—much softer than when he was sitting on the cable (see previous image). (*Lesson:* If you start out with the more difficult posing situation, every other position will seem easy.) I liked how this pose made Nate look as though he were floating in space.

Shooting on black seems challenging, but in realty it's pretty formulaic. The key is to light your subject from the back to create a rim light that separates them from the background—unless, of course, you want the subject's head or body to blend into the background.

As in the outdoor photos, I wanted light from behind my subject, so I added two Profoto strip banks directed toward my subject and a hair light. The backlights metered at f/22 (a bit of overkill in the depth-of-field department).

BEWARE OF FLARE

Although shooting on black is cool, beware of lens flare from the backlights. In this photo I used a 40 degree grid on the hair light, but the light was pointing toward the camera. Without the black foil flag taped (yikes—*taped!*) to the front of the reflector to shield the light from created light flare, I would have been an unhappy puppy. Correcting that problem would have been a postproduction nightmare—and especially regrettable since it can so easily be avoided.

CAMERA DATA

Camera: Canon 7D
Aperture: f/20
Lens: EF 24–105mm at 65mm
Shutter speed: $1/80$ second
ISO: 100

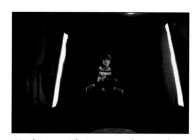

Working with Nate in the studio.

That aperture (f/22) meant that my main light would be set around f/18 to f/20, a stop less than my back lights. In this case, the main light was a medium softbox set up to the right side of the camera at a 45 degree angle to the subject's face.

POSTPRODUCTION TECHNIQUE

After the shoot I uploaded my images into Adobe Lightroom, assigned keywords, picked my favorites, and archived the images to an external hard drive as well as to DVD.

I selected this image as one of my favorites and pumped up the green and turquoise in Lightroom. I then sharpened the image in Lightroom's detail section and exported the image into Photoshop.

In Photoshop, I duplicated the background layer and retouched away the label on the chair using the selection tools and clone stamp tool. I then used the healing brush to get rid of any blemishes, and applied the patch tool to eliminate the highlight on his nose.

Once I was happy with the changes, I flattened the file, saved it as a JPEG, and exported the photo to my White House Custom Color (WHCC) "to print" folder.

Duplicating the background layer in Photoshop.

From the left to right, the Photoshop tool icons for the patch tool, the healing brush, and the clone stamp.

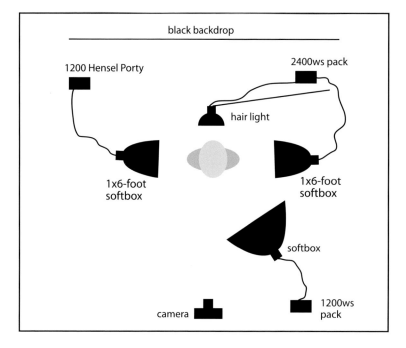

I selected this image as one of my favorites and pumped up the green and turquoise in Lightroom.

The Axman

ASSIGNMENT

I received an e-mail from an art director at *Hearth and Home* magazine asking if I could do a photo shoot in the next three weeks. I e-mailed back and asked what the assignment entailed and how much they paid. Happily, the assignment was intriguing and the price was right for the usage (one-time North American rights and a condition that I not resell the image to a competing publication for a year after the photo had been published).

VISUAL OBJECTIVE

When I arrived at The Axmen (a store and museum in Missoula, MT), I was totally blown away by all the collectibles—from electric trains, to a 1915 Fire Engine, to traffic control items, to (of course) wood stoves and fireplaces. It was not easy to visually organize all these items—but creating a portrait of one of the owners was secondary to the other images for the magazine, which took a little pressure off. I decided to shoot a casual photo of Guy in front of one of the fireplace displays.

POSING AND LIGHTING

I am always thinking "magazine cover" when I shoot for publications, so I framed a strong vertical portrait with space for the masthead.

When I met Guy for the first time I found him to be laid back and pretty enthusiastic about his company—almost childlike, in a good way. When the day came to photograph him, he came in shorts and a sky-blue shirt. To capture

his childlike spirit, I knew I had to put him in a tall chair, where his feet could not touch the ground.

Before he arrived, however, I had set up my lights using my assistant as a stand-in. Making sure my lights are in place and that I am ready to shoot lets me better engage with my subject without worrying so much about the technical aspect of the shoot. I only need to finesse my lighting once I have the real subject in place.

For this photo, I began using all grids on my strobes to accent areas of my subject and his surroundings. I later changed my main light to a large softbox, which allowed me to illuminate more of his body. To compensate for the larger main light, I had to create a large gobo out of black foil to keep the light off the fireplace.

Since my capture also included some ambient light from the store's spotlights, I shot a frame with my X-rite color checker so that I would have an objective color reference and

PAPERWORK

On all my shoots, I have the subject sign an adult or minor model release. Model releases are critical when it comes to building an archive of work that you can resell in the future, releasing you from any potential lawsuits regarding the re-use of the image(s). I also get signed agreements from my clients with regard to the terms of usage for the photograph(s). This prevents any misuse of the image(s) by the client. Don't ever assume you know how a client will use your image(s)—get it in writing.

The before (left) and after (right) selective darkening with the burn tool.

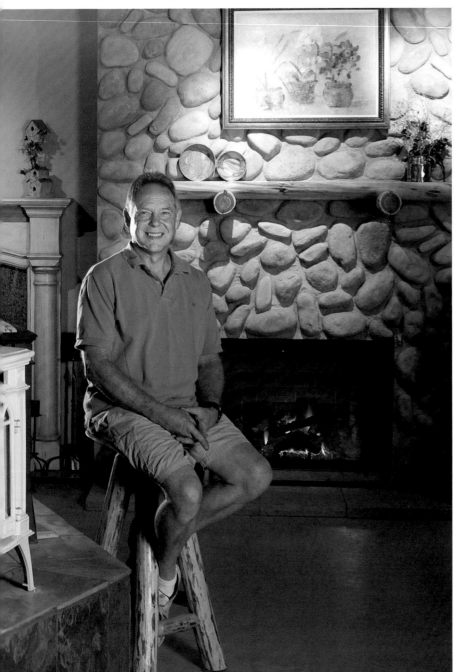

Final image.

didn't have to rely on guessing to decide what the color should look like.

Once I placed my main light and got a reading, the rest of lights fell into place. The accent light, illuminating his back and side, was one stop brighter than the main light. I also placed two 30 degree grids to light the background; one on the fireplace and one on the painting above it. These were set one stop brighter than the main light. The final light, a 40 degree grid, added fill light on the subject. Shooting with just the main light seemed too side-lit; it took away from the happy feeling I wanted to convey in the portrait. I slowed down the shutter to $^1/_{15}$ second to pull in some ambient light (like the glow of the fireplace) and placed my camera on a tripod to avoid camera shake.

POSTPRODUCTION TECHNIQUES

After the shoot, I uploaded my images into Adobe Lightroom, assigned keywords, picked my favorites, and archived the images to an external hard drive as well as to DVD.

I used my custom white balance image to adjust the color temperature then sharpened the image. I also brightened the reds for the fire and darkened the blues for his shirt using the color mixer. Then I synched the remaining images to these settings and made backup copies of the adjusted files.

After the client selected their images (a total of twelve) from the Lightroom gallery I supplied, I went to work retouching them in Photoshop. For this image, I duplicated the background layer (always a good idea) and began to darken areas around the subject with the burn tool set for the highlights and 35 percent exposure. Next, I used the lasso tool to draw out some flames, then cloned the existing flames with the clone tool.

Once I was finished with the selected images I burned two DVDs (one for myself, and the other to the client). I sent the images overnight with my invoice included. The publication ended running six images for their story.

CAMERA DATA

Camera: Canon 40D
Aperture: f/9
Lens: EF 28–135mm at 28mm
Shutter speed: 1 second
ISO: 100

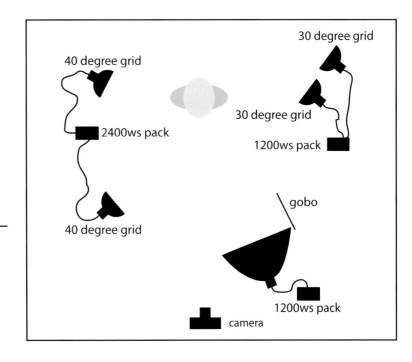

CASE STUDY 7

Kila and Adam

ASSIGNMENT

To promote the retail side of my business I am always thinking of ways to get people into my studio. When I first opened my studio I took advantage of Missoula Downtown's "First Friday" events to promote a gallery show. It was at one such event that Lisa, the mother of Kila and Adam, first saw my work. She was looking for a photographer to document her kids before Kila went off to college.

VISUAL OBJECTIVE

Kila had studied ballet and knew how to "perform" in front of the camera. Her brother was not as confident, but as siblings they were very playful and Kila helped direct Adam. I found their faces to be striking and similar in build, so I wanted to bring them close together—without being so close as to obscure their distinct personalities.

POSING AND LIGHTING

I set up a mottled backdrop and had my basic lighting setup in place before the session. When they arrived, we chatted, chose wardrobe, and then chatted some more.

After our conversation, I had a good sense of the dynamics of the siblings' personalities. Although they both had strong personalities, Kila was more confident. With that in mind, I decided to place her in the forefront with Adam slightly behind. Adam also had a strong personality, so I placed him on an apple crate (any strong box will do) so he appeared a little taller than his sister.

Both Kila and Adam had strong, angular faces, so I fine-tuned my lighting to create Paramount lighting. I added strong accent lighting (half a stop brighter than the main light) to separate their dark hair from the background. I brought the hard accent sidelight around my subjects more than usual to bring out Kila's strong cheekbones.

Clients usually appreciate your input when it comes to selecting images—after all, you are the artist. But it is also important not to be too imposing. That's why editing is very important; I only show the client images I like, but with many options. When possible, I have the client come to my studio once they have narrowed down the selection. I enlarge the images on my monitor and use the "compare" function in Lightroom, nudging them toward what I think is the better image. I also listen carefully for what they want, though—after all, they are the client.

CAMERA DATA

Camera: Canon 40D
Aperture: f/9
Lens: EF 24–105mm at 105mm
Shutter speed: $1/125$ second
ISO: 100

I also placed a hair light with diffusion (spun glass with a piece of black tape in the center) over a 40 degree grid to create more separation between their dark hair and the dark background. A light with a beauty dish was placed to create a circular highlight on the gray-mottled backdrop.

The main light was f/9, the fill (behind the main light) was f/8, the side accent light was f/11, the hair light was f/11 and the background light was f/11.

I picked a few of my very favorites and converted them to black & white using Lightroom.

POSTPRODUCTION

After the shoot, I uploaded my images into Adobe Lightroom, assigned keywords, picked my favorites, and archived the files to an external hard drive as well as to DVD.

Since I shoot all my images in color, I picked a few of my very favorites and converted them to black & white using Lightroom. I then burned a DVD of the selected images for additional backup. I created a lightbox via the web module in Lightroom and sent it off to the client.

The client also agreed with one of the selections I had converted to black & white. She placed an order for a large canvas print and I went to work on it.

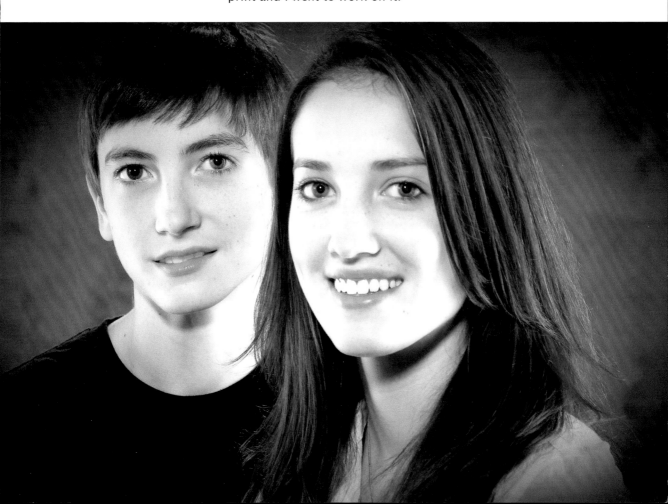

Converting to black & white using an adjustment layer.

Applying the unsharp mask filter.

For my final conversions to black & white I generally use Photoshop. After opening the image, I religiously duplicated the background layer. In the layers palette, I clicked on the half moon icon and chose to create a black & white adjustment layer. In the dialog box that appeared, I played with the levels until I was happy with the results (reds lighten lips, yellows lighten skin tones, blues lighten shadows).

To create a vignette, I selected the burn tool, set it to midtones, and adjusted the exposure to 50 percent. Using a soft brush, I darkened the corners.

The final step for me was to apply the unsharp mask filter. I adjusted the amount and radius sliders until I was happy with the results.

Since I was sending this out to my favorite canvas printing house (Canvas on Demand), I saved the image as a high-quality JPEG to transfer the image via the web for printing.

Burn tool settings.

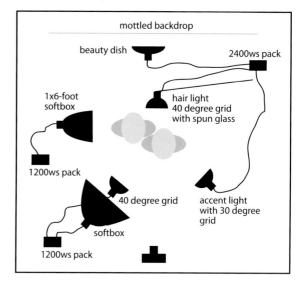

Maternity Portrait: Mizuki

ASSIGNMENT

I'm always trying to find new markets for my work, so I decided to try my hand at maternity photography. I figured that if I could build a client base of women who were pregnant, I would be considered the family photographer and be hired again and again to photograph each family's milestones. The first step was to create a small portfolio of sample images, so I asked friends and neighbors if they knew of any pregnant women who would like to be photographed. The list quickly got bigger and bigger (no pun intended).

STYLE

It's important to distinguish your work from the competition. After researching the market, I saw that most of the other photographers in my market were shooting fully clothed, environmental maternity portraits. To make my work stand out, I chose to shoot against a black background, use side lighting, and have the subjects semi-nude. The style I selected may not appeal to all people—but the bottom line is it appealed to me and set my studio apart in clients' minds.

CAMERA DATA

Camera: Canon 40D
Aperture: f/11
Lens: EF 24–105mm at 105mm
Shutter speed: $^1/_{200}$ second
ISO: 100

VISUAL OBJECTIVE

Mizuki was a great subject to start with on my journey. She was uninhibited and willing to "try this" (my favorite direction to give subjects). I wanted to create a body of work that would isolate each subject and really show off her beautiful pregnant body. I chose a black backdrop to achieve this look. The challenge was to see the right form and light the subjects to outline their bodies.

POSING AND LIGHTING

I had Mizuki wrap fabric around her chest and used an A-clamp to secure it. To see her form, I had her turn sideways and then rotate her hips clockwise. I added a window fan (clamped to a stool) to create some movement in her hair.

To create symmetry, I asked Mizuki to place her left hand on her head and her right hand on the lower part of her belly. This added a nice visual flow through the frame. I often ask my subjects to close their eyes to relax, then open their eyes on the count of three. But while I was looking at Mizuki with her eyes closed, I saw the shot. She was completely serene.

Shooting on black is all about separation lighting. Your objective is to place the lighting so you differentiate your subject from the black background. In this image, I started by setting up my main light and taking a reading. I used a medium softbox in the vertical position and powered it to f/11. Once I had that reading, I knew that all the other lighting had to be a

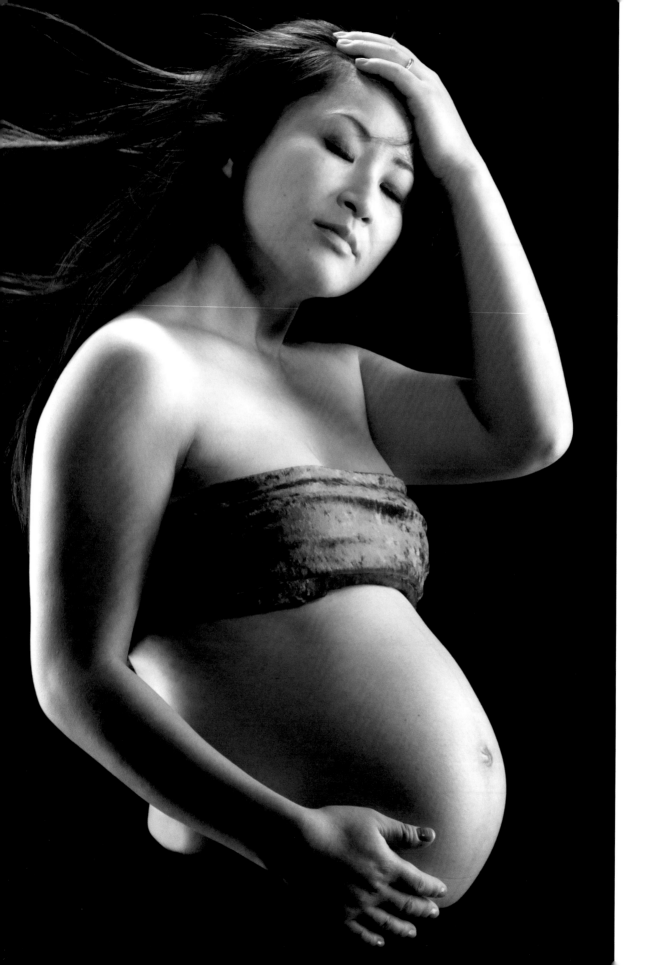

stop brighter. I simply set up two softboxes behind and on the sides of my subject. I also added a hair light with a reflector and 40 degree grid, set at f/16.

POSTPRODUCTION TECHNIQUES

After the shoot, I uploaded my images into Adobe Lightroom, assigned keywords (Mizuki, maternity, pregnancy, etc.), picked my favorites, and archived the files to an external hard drive as well as to DVD.

I used the spot healing brush to get rid of some stray hairs.

The accompanying image was one of my two favorites, so I converted the image in Lightroom to black & white and exported it into Photoshop for more local changes. (*Note:* As previously discussed, you could also do the black & white conversion in Photoshop—or even use Nik Silver Efex Pro2 to create the look of silver halide in your black & white conversions.)

In Photoshop, I adjusted the levels. After duplicating the background layer, I used the spot healing brush to get rid of some stray hairs. I then applied the dodge tool (set to midtones and an exposure value of 25 percent) to lighten her face with a small, soft brush. After I was happy with how everything looked, I applied the unsharp mask filter, setting the amount at 85, the radius at 1.8, and leaving the threshold at 0.

I flattened the image and saved it as "Mizuki.jpg" to order prints from White House Custom Color.

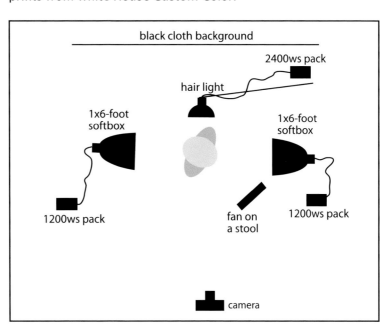

CASE STUDY 9

Maternity Deux

ASSIGNMENT

After seeing the maternity photos on my web site, Maria decided to set up a session. Her family wasn't sure why she wanted a maternity photo (her husband Daren seemed okay with the idea), but she really liked my style. We set up a session two weeks before her due date and hoped she wasn't early.

VISUAL OBJECTIVE

Adding another person to a maternity portrait creates a visual challenge. I had researched other posing ideas for images (father's head against tummy, face-to-face, etc.), but I wanted to show the connection between the two new parents. I wasn't quite sure how I was going to accomplish this, but I felt I would need to gently suggest my ideas during the session. Before the session began, I was a bit nervous (a good sign) since my vision wasn't totally clear.

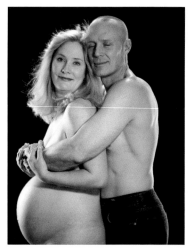

The image before (above) and after (facing page) conversion to black & white.

POSING AND LIGHTING

At first, I covered a mattress with a black cloth and had them lie down on their sides with Daren behind Maria. It looked fine and I got a few good images—but I wanted to better show Maria's pregnancy. I wasn't sure how Daren would feel without a shirt, but he was fine with the idea and my visual idea started to formulate once I saw them together. I am strong believer in the implied, not graphic, visual statement, so I had Daren wrap his arms around Maria to cover her up. I asked him to relax and touch his head to Maria's and think about the joy that was about to be born. He closed his eyes for the image seen here.

I wanted to minimize the shadows on their faces, so I set up my main light with a 30 degree grid directed at Maria's eyes and powered it up to f/13. The setting of f/13 determined the output of all the other lights. I placed a medium softbox to the right of the main light and powered it up to f/11 to act as a fill. I then set up two additional 1x6-foot softboxes for accent

We set up a session two weeks before her due date and hoped she wasn't early.

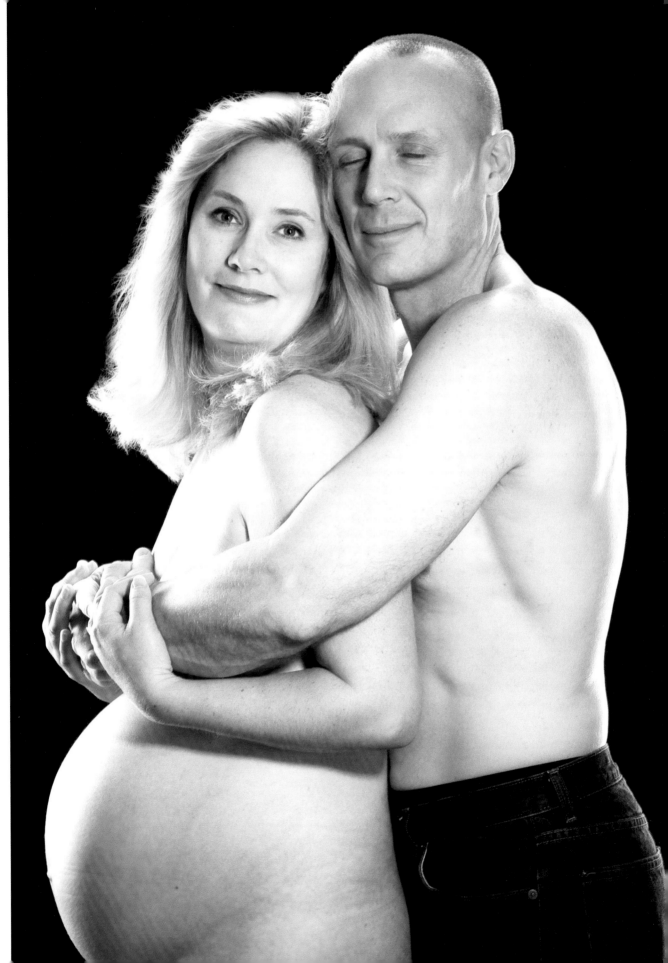

light, placing them on either side of the my subjects to create more separation between them and the black background. These lights were powered up to f/16. For the hair, I used a beauty dish for a wider spread of light across my two subjects. This was powered to f/16. I often mix and match light modifiers to achieve the desired effects—meaning that a beauty dish is not only for the face.

POSTPRODUCTION TECHNIQUE

After the shoot, I uploaded my images into Adobe Lightroom, assigned keywords (Maria, Daren, couple, maternity, semi-nude, pregnancy, etc.), picked my favorites, and archived the files to an external hard drive as well as to DVD.

I converted the image to black & white in Lightroom and exported it into Photoshop for some minor local changes. I began by setting the levels. After duplicating the background layer, I also applied the spot healing brush to get rid of some stray hairs. I then used the dodge tool (with the range set to midtones and the exposure value at 30 percent) to lighten their faces with a feathered brush. After I was happy with how it looked, I applied the unsharp mask filter (amount: 85, radius: 1.8, threshold: 0). I then flattened the image and saved it to order prints.

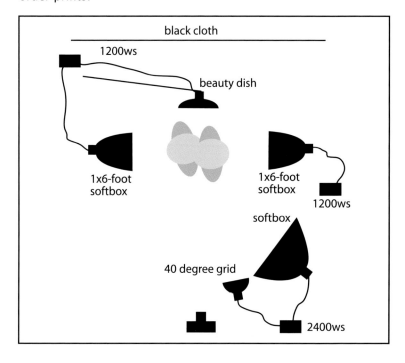

PAYMENT TERMS

Maternity photography is a long process; for this image, the time frame was about six months from booking to ordering the prints. New parents don't quite understand how much their lives will change when a baby arrives, so to avoid any misunderstandings or awkward situations be clear about session payment up front. It is a good idea to get 50 percent payment when the session is booked and the balance the day of the session. When Maria and Daren did order the prints from this session, they selected a large canvas print that now hangs in their bedroom. When I run into Maria, I'm happy to say that she always compliments me about the photograph and how happy she is that she decided to go forward with the session.

CAMERA DATA

Camera: Canon 40D
Aperture: f/13
Lens: EF 24–105mm at 55mm
Shutter speed: $1/160$ second
ISO: 100

Jack Be Nimble

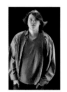

ASSIGNMENT

When I moved from Philadelphia, PA, to Missoula, MT, I knew I'd need to look for new streams of revenue, since my commercial work would thin out in the smaller market. I had photographed CEOs and celebrities—but never high school seniors. I did some research about how many seniors graduated, sized up the competition, and created a marketing plan to start bringing in business.

VISUAL OBJECTIVE

I like to photograph seniors in the studio first before taking them out for a walk around the neighborhood to various shooting environmental. This way I can get them comfortable in front of the camera and find their best side before we head out. (Although teenagers can come across as being very confident, most need a lot of coaching and directing.)

I try to get them talking about their interests and sometimes delve into their personal life, promising never to pass on the information—and (sorry, moms!) I do keep my word about that. The key is to get them engaged and make them feel they are part of the creative process—which they are! I also don't pretend to know their generation or pop culture, which I think they appreciate.

Jack came into the studio with basically one shirt and a t-shirt, wrinkled and unkept, which was cool. I wanted to capture the "Well, this is who I am" side of Jack with a bit of James Dean coolness.

POSING AND LIGHTING

Jack wasn't much for conversation, but knew how to work the camera, so I set up my stormy background and used hard lighting to capture the teenage angst.

I lit the shot as if Jack were coming out of the darkness. For the main light, I set up a softbox to read f/8 on my subject; all the additional lights were one stop brighter (f/11). I added two sidelights, each at a 45 degree angle from behind Jack. The hair light was on a boom stand and had a 40 degree grid spot illuminating his hair. For separation, I placed another strobe head with a beauty dish on a

A GRASSROOTS ENDEAVOR

Building a high school senior business is really a grassroots endeavor. It can be fun and lucrative, but a lot of footwork, socializing, and planning is in order. Like all retail photography businesses, the profit is in selling products—prints, announcement cards, folders, etc. If you are serious about making it your primary source of income, expect to put in a lot of trips to the high school and spend time getting to know the teachers, students, coaches, etc. It truly is a business of referrals, and one happy senior can create many more customers. Remember the parents are paying the bill, so offering great service and incentives should also be high on your list. For me, senior portraits are more of a supplement to the other types of work I do—but in this sluggish economy, I've found it helpful for filling in the slow times.

floor stand, giving an even spread of light on the mottled background. The real excitement happened when I added a window fan (taped to a stool and set on high) and watched Jack's hair fly. The surprise was when I captured that moment of what I call "defiant stillness."

POSTPRODUCTION TECHNIQUE

After the shoot, I uploaded my images into Adobe Lightroom, assigned keywords, picked my favorites, and archived the files to a hard drive and to DVD.

As with most teens, I had to clean up Jack's skin, which meant exporting the image into Photoshop for local fixes. (*Note:* I use Lightroom for global fixes—although Adobe is adding some pretty cool adjustment choices that, in the future, may allow us to do a lot of "photo cleanup" in Lightroom alone.)

CAMERA DATA

Camera: Canon 7D
Aperture: f/9
Lens: EF 24–105mm at 55mm
Shutter speed: $^1/_{80}$ second
ISO: 100

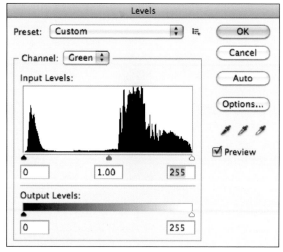

Adjusting the levels in Photoshop.

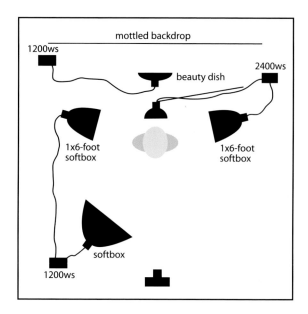

After duplicating the background layer, I went to the levels to check the histogram. I always move the shadow and highlight sliders in (just under the edges of the data at each side) to get the best exposure without relying too much on what I see on the monitor.

Whenever you use a fan and a hair light in a shoot, there are going to be flyaway hairs to get rid of. I used the clone stamp tool with a soft brush to eliminate these. Then I zoomed in on Jack's face and applied the spot healing brush (at 10 percent hardness and 10 percent spacing) to get rid of the skin blemishes. I love this tool and its seamless application; it is a real time saver.

I then used the dodge tool (with the range set at midtones and the exposure value at 30 percent) to lighten his face with a soft brush. I finished by applying the unsharp mask filter (amount: 85, radius:1.8, threshold: 0). I then flattened the image and saved it as for printing. (*Note:* I add an "SP" to my file names for senior portraits so I can easily reference them.)

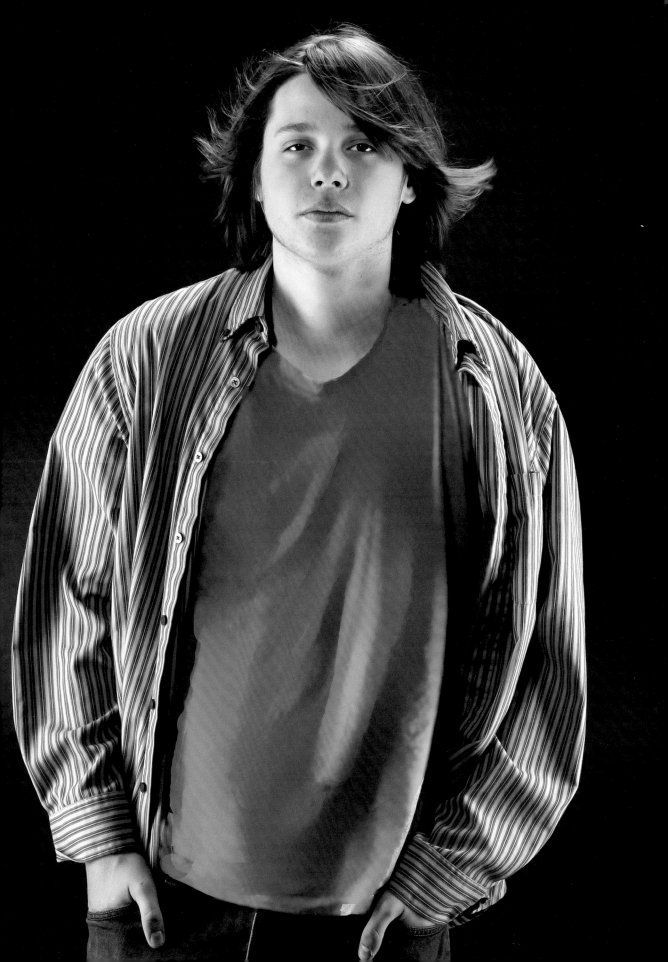

CASE STUDY 11

Take Two

ASSIGNMENT

In all my years of shooting, I had never been asked to photograph the same person again just a year later for the same magazine—until this assignment. When the art director of *Stateways* magazine told they needed another cover shot of Ms. Shauna Helfert in Helena, MT, I was a bit surprised—but also, as any freelance photographer would be, happy for the assignment. The challenge was to come up with something different. My last cover for them (which appears in the previous volume of this series) showed Ms. Helfert sitting outside with the Helena capitol building in the background. This time, I decided to take it inside the capitol.

VISUAL OBJECTIVE

I scouted inside the capitol and picked two locations that I thought would be good. I have to admit, though, that the first location just didn't feel right. I had her on the steps inside the building and was trying to frame a beautiful stained glass window behind her. The angle was wrong, though; I was trying too hard to work with the background rather than concentrating on my subject. Being stubborn, I did the first shot—but I didn't invest too much time.

The second shot was greatly simplified and the focus was back on the subject. (This is a lesson I am always learning!) I had my assistant stand in while I positioned the light and was pretty pleased with the framing. When Ms. Helfert stepped in, I was ready. I had her lean on the banister, which made her feel comfort-

able—and it showed in her face. It helped that the legislature was in session, so her friends would periodically walk by and look at her as if she were a celebrity. That's one of the advantages of shooting in a public space.

I wanted to use the golden background to complement her complexion and blond hair. I also liked the dark silhouette of the sculpture behind her to fill out the frame. Since this was for a magazine cover, I left a lot of room at the top for the masthead.

POSING AND LIGHTING

I normally like to have women stand at more of 45-degree angle to the camera for a slimmer

SMALL FLASH

Sometimes one light is all you need—especially on location shoots. I love using a portable strobe on location, and take full advantage of the light modifiers now available for it (softboxes, globe lights, ring lights etc.). For a successful location shoot, don't forget these four items: 1) gaffer's tape to secure the stands and cords; 2) a weight to prevent top-heavy light stands from falling (*Tip:* Purchase a Bogen Super Clamp with a hook. Attach it to your light stand and hang your power pack on it. It makes a great weight—and less stuff to carry!); 3) a tripod for more environmental shoots that require slow shutter speeds; 4) a cable release to avoid camera shake. Using one will also give you an opportunity to take your head away from the camera and converse with your subject.

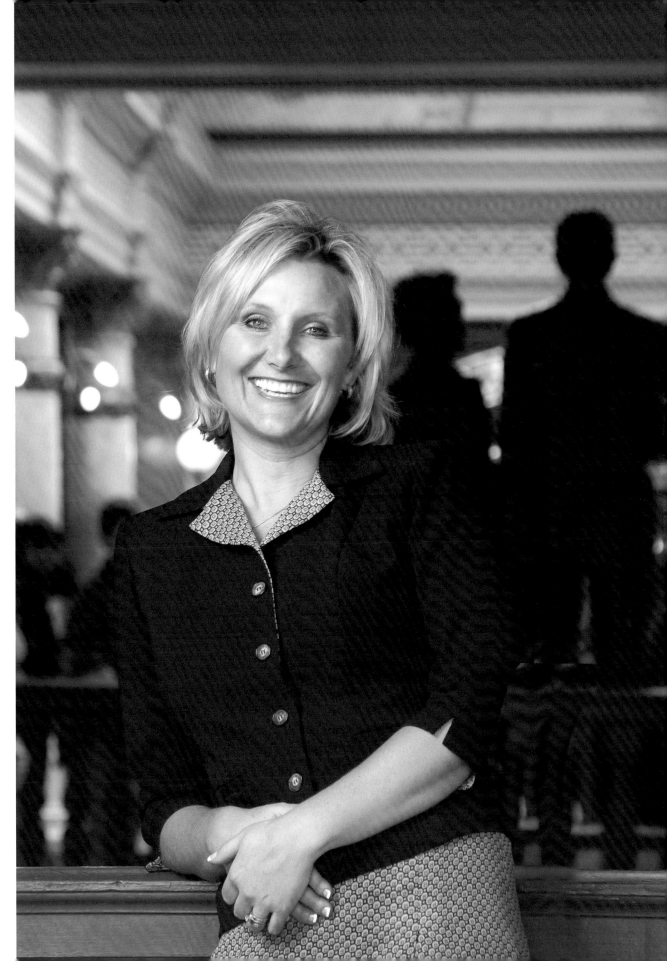

view of their hips. This situation did not allow that, so I subtly trimmed her in Photoshop (more on that below). I had her hold her right wrist with her left hand to create a visual flow and have her do something with her hands.

My assistant and I set up my Hensel 1200ws pack with one head, a medium softbox, and an extra battery. When I do interior location portraits, I like to use strobe on my subject, to keep the skin tones natural, and let the ambient light do its thing. Here, I set my shutter at $^1/_6$ second to warm up the background with the atrium's tungsten lighting. I also used a cable release to avoid any camera shake. I placed the main light to camera left, about six feet high, tilted down a little (I draw an imaginary line from the center of my softbox to my subject's eyes), and at a 45 degree angle to the subject. Simple and effective.

I wanted a shallow depth of field (to keep the attention on my subject) so I powered down the strobe f/5.6. This also allowed me to use a faster shutter speed without risk of ghosting.

POSTPRODUCTION

In Montana, you get used to long car rides. I took advantage of the drive back to Missoula to download the images to my laptop (yes, my assistant drove). Knowing I had the images on the card *and* in the computer made me very happy. When I got home. I went through my complete editing routine, narrowing down my selections to create a web gallery for the client.

Once the final image was selected, I exported it from Lightroom to Photoshop and checked the levels. I then zoomed in and began getting rid of stray hair with the clone stamp tool. I also selected her teeth with the lasso tool, then used the hue/saturation function to set the saturation to –25, reducing any color on her teeth (eliminating it will make the teeth look fake) and slid the brightness to +5. Then I selected her torso with the lasso tool and went to Edit>Transform>Warp (this was created before CS5's Puppet Warp) and pushed in the lower right quadrant to thin her out a bit—just a little. This is an easy way to slim bodies. After light sharpening, the portrait was ready to send to the client for final approval.

CAMERA DATA

Camera: Canon 40D
Aperture: f/5.6
Lens: EF 24–105mm at 105mm
Shutter speed: $^1/_6$ second
ISO: 100

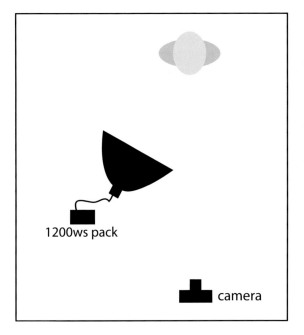

1200ws pack

camera

Corporate Success

A GOOD NICHE MARKET

The market for corporate photography peaked in the 1980s, but it can still be a pretty good niche. Stock photography (especially royalty-free stock) has cut into the market, but current portraits are still needed for annual reports and other corporate collateral. If you are thinking of pursuing this market, you need a pretty solid portfolio of corporate-looking portraits. You can start by photographing your friends, in suits or office buildings. When you have around fifteen good portraits, create a long-term marketing plan to find creatives to look at your work. Finally, when pricing your services, remember that you are licensing your images; the price for an assignment will depend on how the images are going to be used.

ASSIGNMENT

When I got a call from a public relations firm in Chicago to photograph the CEO and executive partner of Grant Thorton International, I smiled. It turned out that the CEO of this very large and successful firm was Ed Nusbaum—someone I knew from my childhood. (If only *I* had done better in math!)

The public relations firm had very specific guidelines for how to photograph the subject. Basically, I was to create a nicely lit portrait, from the waist up, on white. I had started my career in corporate work, photographing CEO's for annual reports, so this was not a strange request. Since I knew this CEO, however, I wanted to take an alternate shot for myself. Knowing that Mr. Nusbaum and I had a history, I was pretty sure he would give me some extra time to be a little more creative.

VISUAL OBJECTIVE

After setting up the CEO-on-white shot (two lights on white seamless, one softbox on the subject, bounce light off the ceiling, and a fill light), I wandered around the corporate office looking for an alternate site. I liked the lobby off the main entrance, which had some interesting furniture and artwork. I knew I wouldn't have much time to set up the second shot, so I previsualized the lighting, had my assistant sit in for the subject, and moved around some of the pottery in the background, creating a visual triangle to pull the image together. Once I was happy with the simple setup, I went back to the "white room" to complete the first part of the shoot.

POSING AND LIGHTING

For the lobby image, I wanted the light to look like a large window was illuminating the scene. The main light was low and close to the camera for three-quarter lighting on my subject. I positioned the softbox illuminating the background higher up than the main light to produce the angled shadows on the

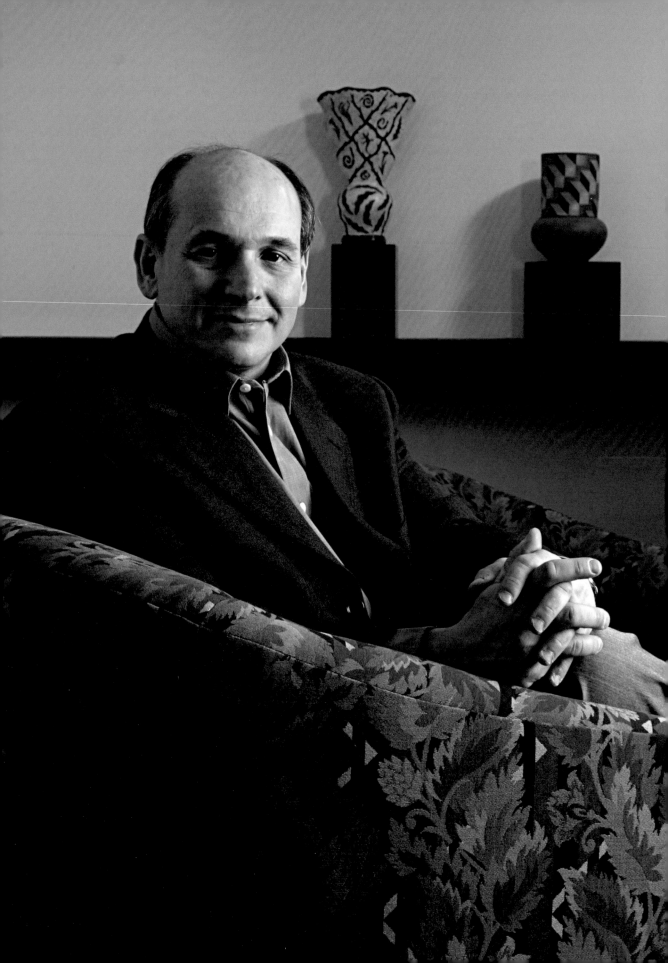

pottery. Once we were set up, I had my assistant go tell Mr. Nusbaum that we were ready.

Even the best preparation can hit a snag. When Mr. Nusbaum arrived and sat in the chair, he sunk; he was not as tall as my assistant. After a quick search, we managed to find a cushion to put him at the right height and we were off to the races.

Being forever influenced by the great portrait photographer Karsh, I am always interested in the hands of my subjects. The classic corporate pose, in my opinion, has the subject's legs crossed, and their hands placed on the raised knee with the fingers intertwined. Here, it worked really well with the chair.

Once Mr. Nusbaum was seated, I saw that the main light was a bit too harsh, so I added a silver reflector on the shadow side of his face to lighten it up. I knew Mr. Nusbaum had a plane to catch, so I didn't want to take up too much of his time (sometimes CEO's will only give you five minutes); once I saw the frame I wanted, I stopped—rather than trying for my usual "just one more."

POSTPRODUCTION

This image was taken in my early days with digital photography; I shot it with my Canon 10D, and all the postproduction was done with Photoshop Bridge and Photoshop CS2—how primitive! (*Note:* Bridge is a powerful tool for organizing, appending, and applying metadata and keywords to your images—not to mention the batch renaming function. In fact, the latest version has almost all the functions of Adobe Lightroom. It's also a great way to preview what's on your hard drive.)

Once the images were imported from the camera, I previewed them in Bridge and starred the ones I liked. After editing, I selected the starred photos and applied the batch rename function to GTNusbaum.tiff, then burned the selects onto a DVD to send to the client.

The image seen here from the shoot was slightly retouched. I imported it into Photoshop and checked the levels. I felt his eyes were a bit too dark, so I used the dodge tool at an exposure setting of 50 on the midtones to lighten them. Finally, I lightly sharpened the image using the unsharp mask filter. That's it!

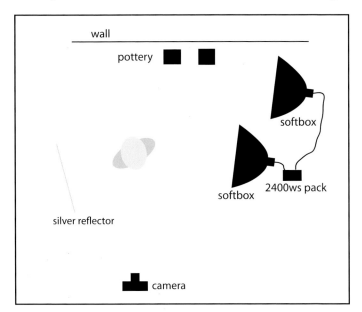

CAMERA DATA

Camera: Canon 10D
Aperture: f/11
Shutter speed: $1/30$ second
ISO: 100

CASE STUDY 13

Men in Skirts

ASSIGNMENT

I received a call asking whether I could photograph dogs. My answer was, "Of course." It turned out that the caller wanted a portrait of himself in a kilt with his dogs for a holiday card. The subject of the photo you are looking at is not the caller, though; I decided to ask a friend, who plays bagpipes and also wears a kilt, to come in before the caller's shoot to do a test session.

VISUAL OBJECTIVE

Thinking about the feel of the photograph I wanted to create helped me decide on what type of background to use and the look I wanted in the lighting. I was looking for an implied stormy blue sky and classic window lighting with a hint of backlight. When Steve arrived at my studio and I saw him in his Scottish outfit carrying his bagpipes, the first word I thought of was "majestic." Posing him more in profile, looking off into the distance, helped to create the "majestic" look.

POSING AND LIGHTING

When you have a great prop and costume to work with, the posing comes easy. I wanted to show all the details of the bagpipes and the uniform and in a very tight composition. Once I had Steve in the right position, it was a matter of finessing the lights to capture the texture and details.

I chose side lighting to pick up the texture of the surfaces. To create the look of window light, I placed a 1x6-foot softbox (at f/11) at camera left to skim his cheek and create separation from the background. For fill, I set an additional softbox (at f/8) closer to the camera but still pointing away from the background. Knowing I'd be using a blue gel on the background light, I set up black gobos between the softboxes and the background to prevent any spill light from compromising the blue tonality.

A TEST SHOOT

I learned early on, when I was assisting an advertising photographer, that when you have a chance to create a test shot before the shoot you should take it. This was a good example of that traditional practice. I was so ready for the actual, paying session that I could relax, concentrate on getting the shot, and have some fun. Working with two dogs and a human subject is no easy task—as I will explain in the next case study . . .

CAMERA DATA

Camera: Canon 40D
Aperture: f/7.1
Lens: EF 24–105mm at 40mm
Shutter speed: $^1/_{160}$ second
ISO: 100

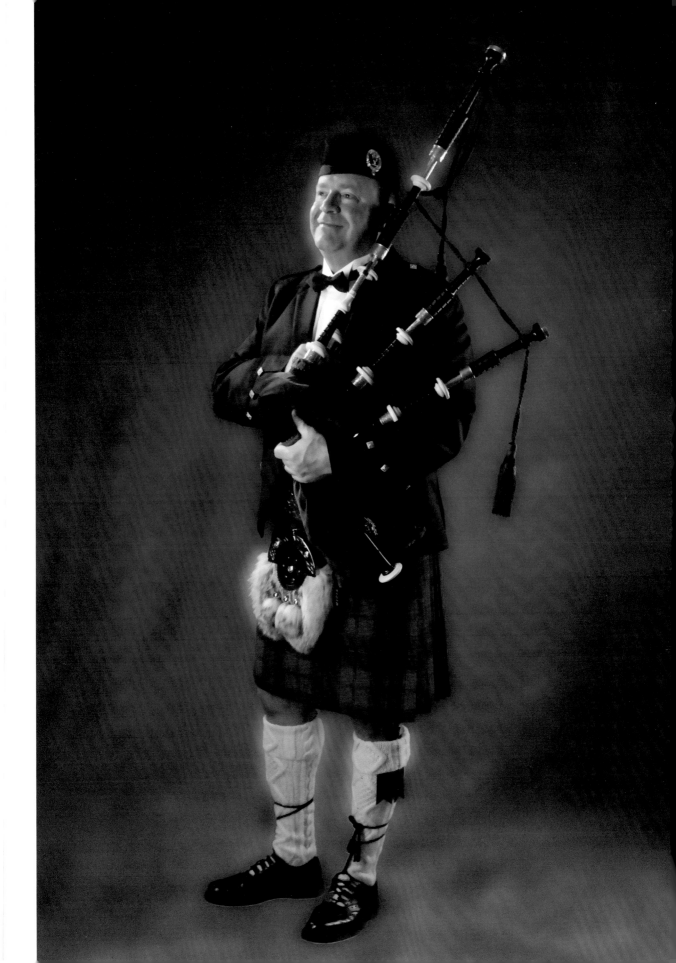

background light toward my subject's hair. I then added another light bank to the right side of the camera, opening up the shadows. Since I was no longer concerned with keeping the background blue, so I removed the gobos.

POSTPRODUCTION

Once the shoot ended and the dogs were loaded into the car, I downloaded the image and applied keywords. I did a broader edit than normal to give my client plenty of options. I then created a web gallery and sent my client a link to it—along with a note of thanks.

I did a broader edit than normal to give my client plenty of options.

Once the client selected his favorite image, I brought it into Photoshop and duplicated the background layer. I then began to retouch the image. First, I selected the background and applied a light Gaussian blur. I then inversed the selection and applied the surface blur filter to smooth out Jim's face and body.

I felt the dogs' faces were too dark, so I set the dodge tool's range to shadows and chose a 25 percent exposure to lighten their faces. (Be sure to check the "protect tones" box to minimize clipping and keep the colors from shifting.)

After flattening the image and saving it as a high-resolution JPEG, I inserted it into White House Custom Color's "Walden" template and added the text the client requested in the card.

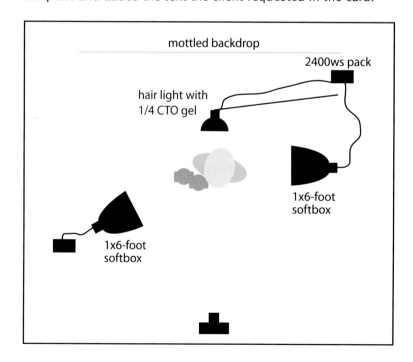

CASE STUDY 15

Commercial Portraits

ASSIGNMENT

I was asked by a design firm in Missoula to photograph the employees of a local insurance company. The final images would be black & white and used for billboard-size posters. Knowing how big the final images were going to be, I asked the client if I could rent a Hasselblad H3D-39 with a 120mm lens. I got the go-ahead and had a steep learning curve ahead of me. It was a two-day shoot, so I rented the camera for a week—and by the time of the shoot, I had camera envy.

VISUAL OBJECTIVE

Most of the images for this job were to be tight head-and-shoulders shots with dramatic lighting and a nondescript background. In addition, however, they wanted a group shot that would emphasize one person of the group. Therefore, the visual objective of this image was pretty straightforward; I simply used a shallow depth of field to isolate the main subject.

POSING AND LIGHTING

I scouted the site beforehand and found that their lobby was open, had signage, and was primarily lit by window light. I wanted to maintain the look of that light but needed a strobe to freeze my subjects. I set up a large light bank and powered it way down so that I would have an f/4 reading on my subjects. I checked the ambient light and it read f/4 at $^1/_8$ second. I wanted the strobe to overpower the daylight to avoid ghosting if my subjects were to move, so I sped up my shutter to $^1/_{15}$ second.

The logistics of posing were based on gender, height and color of wardrobe. To get them to all look at the camera and smile, I use my tried-and-true direction of telling them to bounce, which always gets a smile. Since I was shooting at a slow shutter speed from a tripod, I had them bounce while I counted to three, then stop bouncing and smile.

90 PERCENT PLANNING

Commercial photography is 90 percent planning and 10 percent shooting. It is important to ask lots of questions—and ask for the world in order to produce the best possible image for the client. When I got this call, my first question was about the usage of the image. Based on that information, I could determine a licensing fee and get an idea of what they were budgeting for the shoot. I knew it would be expensive to rent a $30,000 camera and lens for the week—but I also knew it was important for the final usage of the images. Once I explained my reasoning to the client, he agreed and the final images proved to be successful.

CAMERA DATA

Camera: Hasselblad H3D-39
Aperture: f/4
Lens: 120mm
Shutter speed: $^1/_{15}$ second
ISO: 50

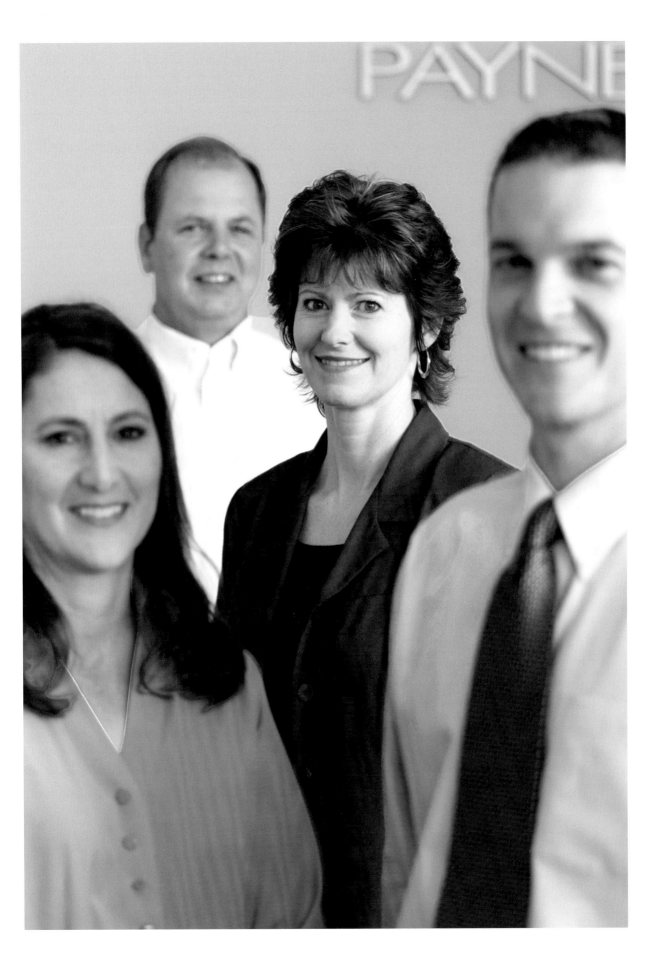

POSTPRODUCTION

The H3D-39 is truly an incredible camera, but it eats computer memory. Each file, unprocessed, was 39MB; by time I converted them to TIFFs, they averaged 110MB. The H3D-39 has its own RAW format, which means you have to process the file through the Hassleblad software. Knowing how big each file was, I tethered the camera to my laptop while I was shooting. I also saved a lower resolution file to the CompactFlash card in my camera. As the images downloaded to my computer, I sent them to be converted to TIFFs so I could review them in Adobe Bridge.

It is amazing how critical one becomes of what images to keep and throw into the trash when your computer is running low on memory. I eventually created a tight edit and placed the images into a desktop folder. At the conclusion of the shoot, I had about 60GB of images.

Since the ad agency had a professional postproduction person, my job was to deliver the images basically untouched. Normally, I would either create web gallery or burn the images onto a DVD—but that would have taken a week. So I asked client if they could loan me an external hard drive to download the images. They obliged and sent me a 1TB external hard drive.

I later heard back from their postproduction guy who said that the images were great to work on. The large files made it easy to do any retouching—and when converted to black & white, the detail on the faces was incredibly sharp.

I eventually saw one of the images as a Duraclear display in the airport. It was presented at about 4x5 feet—and it certainly looked pretty impressive!

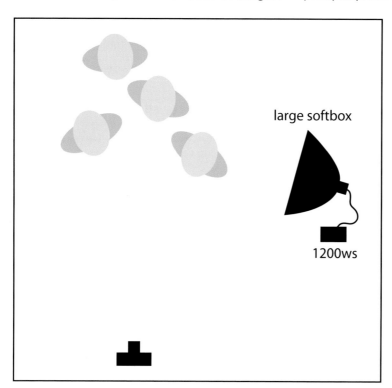

large softbox

1200ws

Father and Son

ASSIGNMENT

The Wheeler family traveled from Bozeman to enjoy a weekend in Missoula and happened to come into my studio during a "First Friday" open house. The father, Clark, looked through my book *Fathers and Sons* and asked if he could hire me to photograph him with his son.

VISUAL OBJECTIVE

Having shot literally hundreds of father-and-son(s) portraits, I had strong ideas about what I was looking for with this close, fun family. The father also had some ideas about wardrobe and style, which is always helpful. I felt a black background was a good way to isolate the subjects and limit any distractions.

POSING AND LIGHTING

I wanted to show the closeness of this relationship, so I had the father straddle a low chair, then had his son come down to him, hugging him from behind. The short chair forced Clark to stretch out his legs, revealing his casual demeanor—and his boots.

I asked the son, Nason, to wrap his arms around his dad and had Clark reach up and hold his son's arms. Once they were in place, I instructed Nason to squeeze his dad as tight as he could on the count of three. We did this for a while—until it became silly and I got what I wanted.

Shooting on black, I like to set up accent lighting. These lights, directed at the subjects' sides and backs, create form and separation from the background. In this case, I began with my main light, a medium softbox that exposed my subjects at f/11 and $^1/_{125}$ second. The accent lights were then set to around f/16. These included two long, 1x6-foot softboxes for side lighting. I also set up a hair light on a boom stand, using a beauty dish to spread the light and add highlights on their hair.

POSTPRODUCTION

After the photo shoot, I backed up my images and added keywords using Adobe Lightroom. (*Note:* I use metadata presets for studio portraits to streamline this process—but be sure not to make these *too* specific; otherwise, you'll have to adjust them all the time.) After I sent a

THE ART OF OBSERVATION

Photography is truly the art of observation. To observe you must be open and present from the moment your client walks into your studio. A good portrait photographer will identify, almost immediately, the qualities and the character of his/her subjects. This does take training, experience, and intuition. There is always a little bit of you in the subjects you photograph, so use that to help you design personalized portraits. I incorporate universal symbols into many portraits in order to communicate with a broad audience. As the ancient Chinese proverb states, "Seeing it once is better than hearing it one hundred times."

Metadata presets.

Using a black & white adjustment layer.

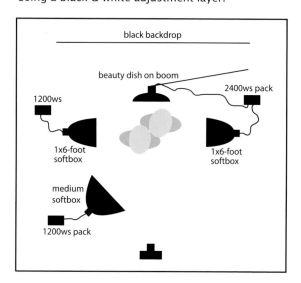

black backdrop

beauty dish on boom

2400ws pack

1200ws

1x6-foot
softbox

1x6-foot
softbox

medium
softbox

1200ws pack

web gallery link to my client, I waited to hear what his order would be. Then, I advised him about the different print packages I offer that could save him money. As with all my clients, I also asked if he would like to come in to review the images on my monitor—where I can show what the shot looks liked cropped, converted to black & white, and in comparison with others from the session.

This also gives me a chance to discuss how much they want their images to be retouched. I have found this method to be very helpful—both to my customers and to me.

The image on the facing page was one of their selections. While it was originally shot in color, they decided to order it in black & white. So, I brought the image into Photoshop, duplicated the background layer, then checked the exposure and slightly tweaked the levels. From the layers palette, I created a black & white adjustment layer and played with the tones until I was happy with the results.

A little work with the dodge tool was done to lighten the faces slightly. I also used the clone stamp tool to eliminate some stray hairs.

After I was happy with all the adjustments, I flattened the image and applied light sharpening with the unsharp mask filter.

CAMERA DATA

Camera: Canon 40D
Aperture: f/11
Lens: EF 24–105mm at 32mm
Shutter speed: $^1/_{125}$ second
ISO: 100

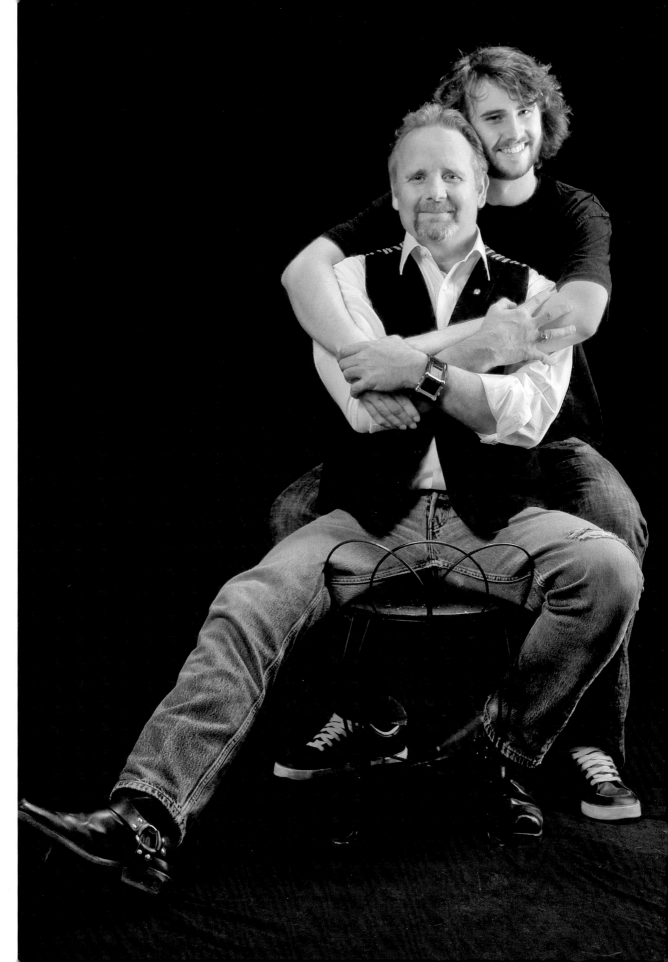

CASE STUDY 17

Fantasy Fotography

ASSIGNMENT

I sometimes do pro bono work for a non-profit organization that uses my images in their fund-raising posters. Wanda saw one of these posters and decided that I was the right artist to create a fantasy photograph for her boyfriend.

VISUAL OBJECTIVE

I had never really created fantasy work—but Wanda was impressed with my maternity photographs and felt I knew how to light the body. When she called and told me about her concept of being a fairy, my imagination started flowing. She would bring the costume and tree branches and I would set the mood with lighting. My objective was to create something magical and whimsical—something that might be found in *A Midsummer Night's Dream*.

POSING AND LIGHTING

I started out by having her stand draped in gauze, but it seemed too melodramatic. I thought it might be better if she sat as though she were staring into a pond. I also wanted to have her appear mischievous and somewhat coy. The positioning seemed to work and the image was coming together. I lowered the branches (taped onto light stands and cross-bars) to make it look as if she were in the middle of the woods and enveloped by the tree.

I set up the lights as if it were dusk, using a gray mottled backdrop and gelling the gridded

PRO BONO WORK

I recently read an interesting debate on a photography forum about whether photographers should accept pro bono work. In truth, I believe it all depends on what the photographer will get in return. I only consider a pro bono job if:

1. The organization is non-profit
2. I believe in their mission
3. All published work is properly credited (in a way that's large enough to read!)
4. Digital versions have a link to my web site
5. All expenses are paid
6. In return, I receive something tangible (like a symphony ticket, product, etc.)

A lot of organizations will try to convince you that donating your services will make your business flourish—and that may or may not turn out to be true. If you decide there are sufficient potential benefits, you may decide to take the job. For example, I take only one or two pro bono jobs per year, but the paying job seen here happened to be generated by one of them. Wanda saw posters that the non-profit organization had hung up around town—with my credit line—and she liked what she saw. She went to my web site and felt I was the right photographer for her needs.

If you don't see good potential benefits, you may want to decline the job. And if a pro bono job you do accept fails to generate paying jobs throughout the year, you may want to consider opting out of the project next time.

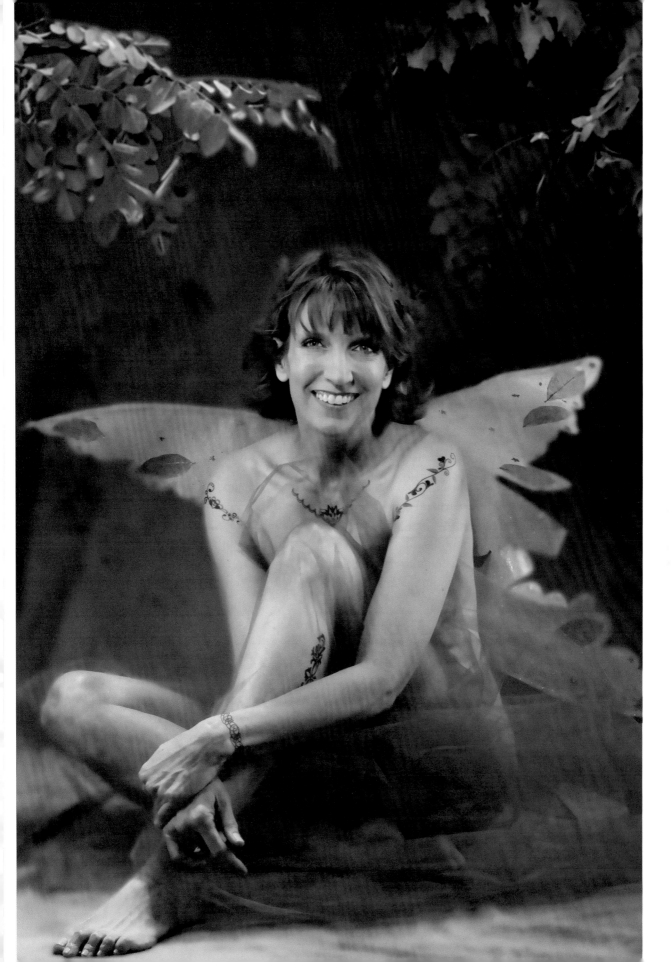

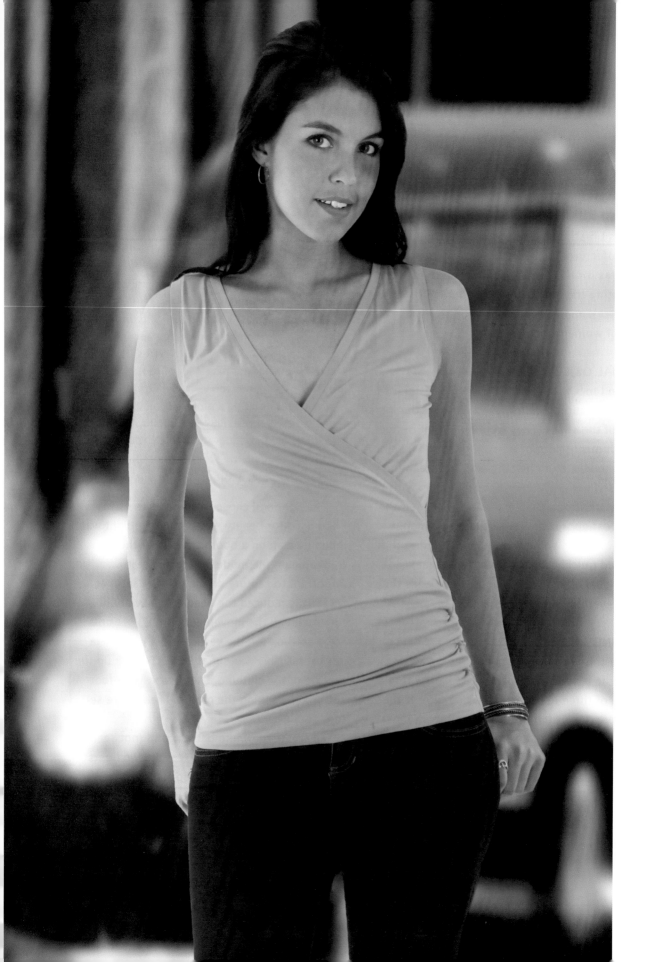

onto the metal reflector (between the light and the model). I then powered up the two lights to f/16.5. To get a pure white background, the background lights should be at least one stop brighter than your main light.

To avoid flare from the background wrapping onto your model and compromising the sharp edges, take your light meter behind the model and direct its sensor toward the background for a reading. If the reading is equal to or more powerful than the main light, move the model forward or power down the background light.

POSTPRODUCTION

One big advantage of working with models and makeup/hair stylists is that there is less to do on the postproduction side of things—unless you want to "stir the pot." This client was more interested in getting their images ASAP, since they were under a printing deadline.

During the shoot, as I filled each CF card, I had my assistant download the images into Lightroom and enter a few keywords (Neesha, fashion, catalog, etc.). To save me time and money, I arranged to borrow a hard drive from the client to deliver the images (rather than burning them to twenty DVDs!). Happily, the client also preferred this approach.

After the shoot, however, I got to thinking about all these images of models on white— shots that were perfect for compositing. One idea I had was to drop in a close-up of the garment behind the model to show off the quality of the fabric. I did just that and showed it to the client—who loved the idea and used it in their catalog (brownie points!). For this image, I decided to combine the modern-looking image of the model with a rustic background.

The first step was to import the image of the model into Photoshop, duplicate the background layer, and make a few little adjustments (refining the levels, cleaning up loose hair, etc.).

Then, I imported the image of the old car into Photoshop and duplicated the background layer. On that duplicate layer, I applied the Gaussian blur filter to throw the image out of focus.

Next, I went back to the model shot and used the magic wand tool to select the white background. I then inversed the selection so that the model was selected. I copied the model to the clipboard by hitting Cmd/Ctrl + C (or you could go to Edit>Copy).

Finally, I returned to the car image and hit Cmd/Ctrl + V to paste the image of the model onto the car image. To complete the image, I scaled the model proportionally to the background by going to Edit>Transform>Scale.

Voilà—catalog composite complete!

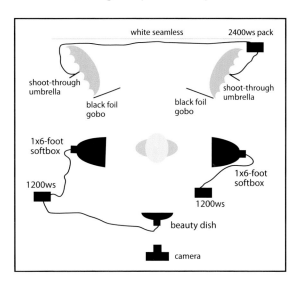

CAMERA DATA

Camera: Canon 7D
Aperture: f/11
Lens: EF 24–105mm at 95mm
Shutter speed: $1/200$ second
ISO: 100

CASE STUDY 19

Every Woman Matters

ASSIGNMENT

I received a call from Meg Traci of the Rural Institute of the University of Montana. She had a project in mind, which was inspired by my wife, to create a multimedia project that would raise awareness of how difficult it is for women with disabilities in the Montana community to receive proper cancer screening. After meeting to discuss the project, we decided to profile twelve women from around the state with those concerns. I would take their portraits and Jeremy (an adjunct professor at the University of Montana) would film the interviews.

This is one of those volunteer projects I felt fit all my criteria for donating my services (see the sidebar in the "Fairy Fotography" case study for more on this). The "Every Woman Matters" campaign is part of the Center for Disease Control's "Right to Know Project." As it turned out, the project put me on the front cover of the local newspaper, got some television exposure, and brought over three-hundred visitors to my studio for opening night. Best of all, the exhibition of twelve 4x5-foot canvas prints is still touring the state three years later.

VISUAL OBJECTIVE

I wanted to isolate each woman on black and create a very theatrical appearance in the portraits. I wanted each woman to engage the viewer by looking directly into the camera—but I also wanted to reveal a little about their personalities. Their stories were heartfelt and inspiring, so I wanted to convey that message without any visual clutter

POSING AND LIGHTING

When I was speaking to Jessica Cantrell, the subject of this image, I found out that a quilt had been made for her while she was going through cancer treatment. It made sense to me to use the quilt as a wrap to symbolize her struggle. I liked the

DO YOUR HOMEWORK

When you enter into a project, it's important to decide what you want and commit yourself to it. In this case, it was important for me to meet the clients and get an idea of what their objectives were. I was lucky enough to work with clients who trusted my aesthetics. I also did some research on the project and spent some time with each subject before her session. By the time the actual shoot happened, everything went quickly and without a glitch. The photographs still travel around in an exhibition—continuing to generate interest in my work.

CAMERA DATA

Camera: Canon 40D
Aperture: f/11
Lens: EF 24–105mm at 28mm
Shutter speed: $1/200$ second
ISO: 100

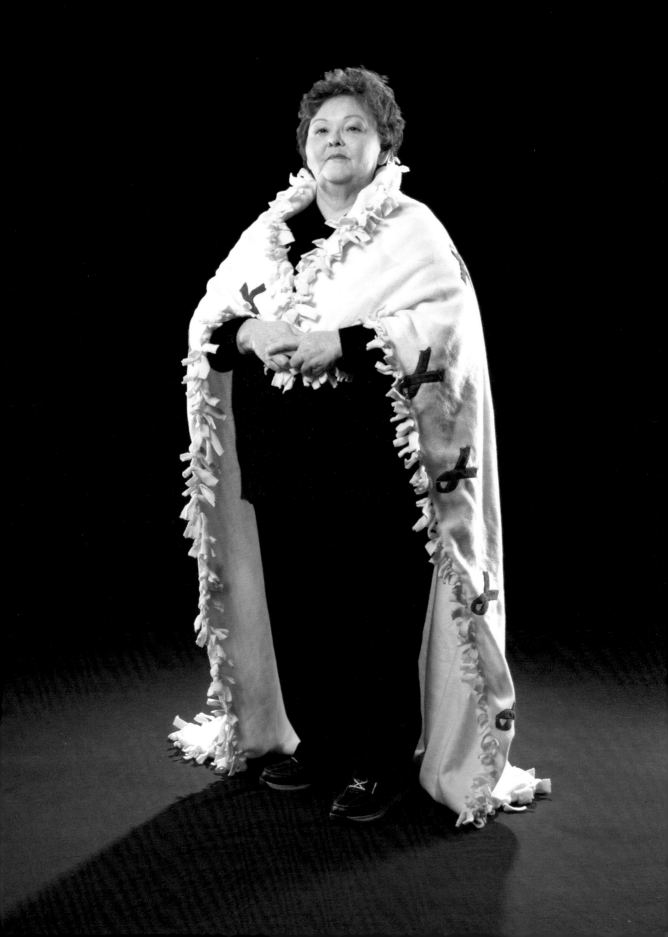

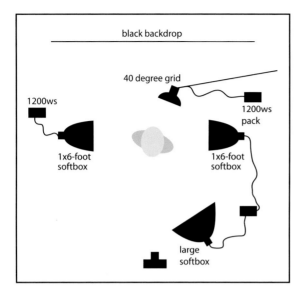

The lighting for these twelve portraits was basically the same—my sure-fire black background lighting setup. I placed the main light, a large softbox at f/11, to camera right. All the additional lighting was set a stop or more brighter than the main light. I set up two 1x6-foot Profoto striplights, placing them on each side of my subject and dialing them up to f/16. I added a hair light (a 40-degree grid) on a boom stand and dialed it up to f/16. Even though I was shooting in color, I knew I would be converting all the images to black & white, so I pumped up the side and hair light a little more to increase the contrast.

sense of protection it communicated and how it suggested her Native American heritage. When she wrapped the quilt around her, she looked so noble. I had her stand up straight, chin up, and look at the camera with a subtle expression (neither happy nor sad). I had her clasp her hands together to hold the quilt and symbolize closure.

POSTPRODUCTION

After the shoot, I backed up my files, applied keywords, and edited down to my favorite three shots. The final selected image was then exported into Photoshop from Lightroom as a PSD file.

I began by duplicating the background layer. For this example, I wanted to isolate the breast

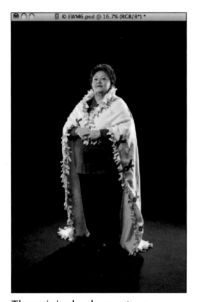

The original color capture.

Creating the black & white adjustment layer.

Adjusting the tones in the dialog box for the black & white adjustment layer.

The layers in the final black & white conversion.

cancer symbols on her quilt and used the quick selection tool select them. Once they were all selected, I went back to the quick selection tool and held down the Alt/Opt key to deselect the little circles inside the loop of the ribbon. I then went to Select>Inverse, which selected everything but the ribbons. Using the half-moon icon at the bottom of the layers palette, I created a black & white adjustment layer. In the dialog box that appeared, I moved the sliders to adjust the tones in the image. Since the ribbon icons were not selected, they remained pink.

I then flattened the image and saved it as a TIFF to send out to Canvas on Demand, who printed all of the images for the exhibition.

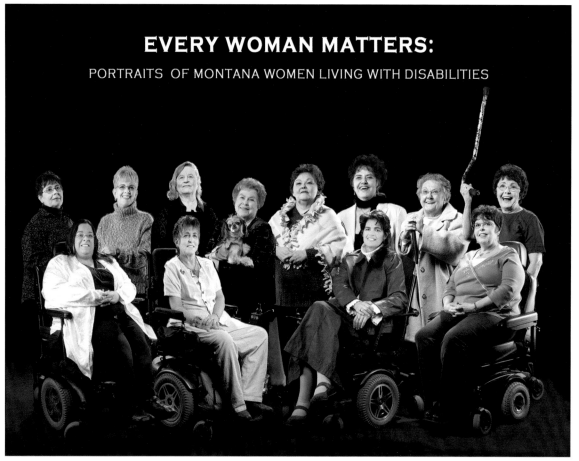

This is a composite of all twelve women that was used as the poster to promote the exhibition.

CASE STUDY 20

Granite Man

ASSIGNMENT

I got a call from a local agency to shoot a new ad for a company that sells granite. They had arranged the location and the model while I helped with the wardrobe and props. The concept was to show a middle-aged man enjoying the morning in a kitchen filled with granite counter tops.

VISUAL OBJECTIVE

Showing off the elegance of the granite counter top was paramount—but keeping the counters clean and color correct while still giving the image a feeling of warmth was very challenging. Fortunately, I was able to scout the site before the shoot and frame the shot, which made it easier to figure out the lighting.

POSING AND LIGHTING

Working with a small agency has its advantages—but it usually comes with low-budget, do-it-yourself styling. In this case, I brought along a red terry-cloth robe and Boden coffee cup. On a shoot with a bigger budget, a stylist would be hired to relieve the photographer of any responsibilities for propping and dressing the shot. Either way, it always seems to work out.

I shot this image with a 10-22mm Canon lens. This is not a lens I typically use for portraits, but in this case I needed to exaggerate the counter top and position myself so that there were no background distractions. To avoid distortion on the subject, I centered him in the frame—knowing I could adjust the background distortion in Photoshop or Lightroom.

We started with the subject in a dark robe and reading the newspaper, but I felt the shot need some color. I also thought that the large newspaper sheets covered up too much of the counter. Se we switched to a red robe and coffee cup, posing the subject with a book. I wanted to create the illusion that someone had just walked in and he was chatting with them. I

CAMERA DATA

Camera: Canon 40D
Aperture: f/16
Lens: 10-22mm at 10mm
Shutter speed: $1/8$ second
ISO: 100

RE-SHOOTS

When I didn't hear from the client for a while, I began to worry. As it turned out, the client decided the model wasn't quite right and asked if I would do a reshoot for free. I said no, but I did offer a discounted rate. Given that they changed their mind after the fact, I felt I should be paid for the reshoot. From this experience, I learned to be more diligent about agreements before the shoot—regardless of my past experience with the client. A contract should have been signed between my company and the client, laying out the terms of our agreement and, more specifically, the terms of any reshoot.

had him take off his glasses and look to the side as if it were spontaneous.

I wanted the look of warm morning light on my subject but did not want to shift the color of the counter top. To do this, I set up a large softbox to the right of the counter. I added a silver reflector on the left side of the counter to kick light back onto the counter. I then set up a kicker light with a 40 degree grid and black wrap shaped around the reflector to funnel light onto the subject but not the counter.

As I looked through the viewfinder, I had my assistant set up two additional lights that bounced off white cards on the ceiling (just out of the frame at both corners of the room) for fill light on for the background.

My first meter reading was the main light, which was f/16. Knowing this, I powered up the kicker light to f/22 and placed a full CTO gel over it to create the look of morning sun. I didn't want to overpower my subject, so I set the two additional lights to read f/11. To capture the ambient light in the kitchen, I set my shutter speed at an $\frac{1}{8}$ second (dragging the shutter). To avoid ghosting or camera movement when using this technique, shoot from a tripod with a cable release—and, if possible, activate the mirror lock on your camera. Before I actually started shooting, I set up my X-Rite Passport Color Checker to use later as a reference for color accuracy. This is very important in product photography.

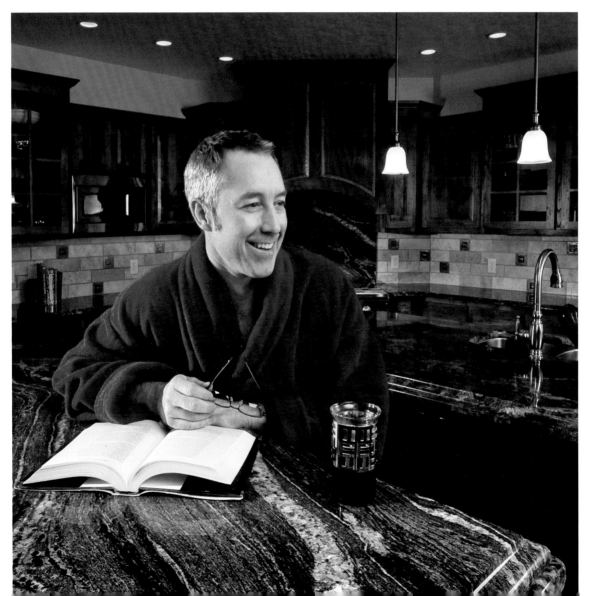

POSTPRODUCTION

When I got back to my studio I imported the images into Lightroom. After making my picks, I opened up the color checker image and used the white balance tool (in the develop module) to pick the neutral gray patch. The result was a more accurate color balance. I then sharpened that image. I selected all the picked images and synchronized the white balance and sharpening to all the images. After applying keywords, I created a web gallery to send off to the client.

The image seen here was my personal pick. It didn't require much retouching, but I did use a few tricks to enhance the photo. Working on a duplicate of the background layer, I selected the entire image and went to Edit>Transform>Perspective and straightened all the lines. This cropped out some of the image, but I had taken that into account when shooting.

Another nifty trick is to select the light sources with the quick selection tool. Then, open up the curves, switch to the blue channel, and pull the line up to increase the blue (making the lights less yellow). With the selection still active, go back to the composite RGB channel and pull down on the top right side of the line to darken the lights. Pretty cool (pun intended).

The final step was to go to Filter>Sharpen>Unsharp Mask and sharpen the image. I set the amount to 126; the radius to 1.8, and the threshold to 2. I then flattened the image and saved it as both a TIFF and a high-quality JPEG.

Choosing the perspective setting to correct distortion.

The quick selection tool.

Adjusting the levels of the blue channel.

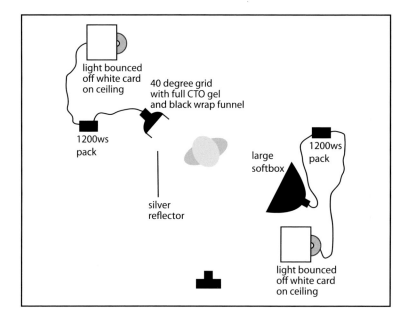

A Couple of Realtors

ABOVE AND BEYOND

This shoot was a good example of making something beyond what was expected. Initially, Tammy and Bob were just looking a good commercial shot for their real estate business. By the end of the session, however, I was creating a "couple portrait." They ordered a large canvas print for their home—which meant a happier client and additional revenue for me. Give the client more than what they ask for and you will be rewarded.

CAMERA DATA

Camera: Canon 40D
Aperture: f/11
Lens: EF 24–105mm at 70mm
Shutter speed: $^1/_5$ second
ISO: 100

ASSIGNMENT

I received a call from Tammy who had gotten my name from a client. She and her husband, Bob, were looking for some portraits of them together for their real estate business. Normally, realtors have individual portraits to put on their web site and business cards. This was far more interesting since it would be a portrait about a relationship.

POSING AND LIGHTING

When the couple came to the studio, I wasn't sure what to expect since I hadn't seen or met them before—and realtors come in all shapes and sizes. I immediately felt warmth from them and they appeared to have a very loving relationship. We started out with more traditional wardrobe selections (business casual) for the professional shots. Once we were finished, however, Bob put on his leather coat and Tammy put on her black turtleneck. That's when the real portrait session began.

To convey the warmth they had for each other, I had Bob hold Tammy. On the count of three, I asked him to squeeze her and look in the camera. When he went to kiss her on the cheek, I reverted back to my photojournalism days and yelled, "Look this way!" Bob turned his face toward me and Tammy put on a big smile—with a snap (or a click), the shot was taken.

The lighting setup is what I call my three-light special. The main light was a large softbox, powered down and placed as close to the subjects as possible without being in the frame. This was set at f/10. The second light was a 1x6-foot softbox for skim light to pick up the texture of the leather coat and create the look of late-afternoon sunlight. This was set at f/14. The third light was a beauty dish on a floor stand and directed toward the mottled gray backdrop. This created a round, feathered light behind them, separating subjects from background. This light was set at f/16. That's it!

Checking the levels.

Converting to black & white
using an adjustment layer.

POSTPRODUCTION

In Lightroom, I tagged the shots for their commercial venture with the letter P and tagged the personal images with the letter P plus one star. I then filtered the "P" images and the "P-plus-a-star" images so they all appeared in a grid in the Lightroom library. I selected them all and added keywords (Bob and Tammy, realtors, portraits, man, woman etc.). Then I synched my metadata, created a web gallery, and sent the URL to the clients. I burned the selected images to a DVD and trashed the ones that weren't selected.

Once the image seen on the facing page was chosen, I exported the file to Photoshop and went to work. My first move was to duplicate the background layer. After checking the levels, it was time for black & white conversion. Next, I whitened the eyes and teeth. To do this, I used the quick selection tool to select the whites of their eyes and her teeth. I then went to Image>Adjustments>Hue/Saturation and reduced the saturation to –12 and increased the lightness to +10 (these are very subjective settings). I then used the blur tool at 50 percent to soften under Tammy's eyes. Finally, I applied light sharpening using the unsharp mask filter. After flattening the image, I saved it as both a high-resolution JPG and a PSD file and placed the images in a folder on my desktop.

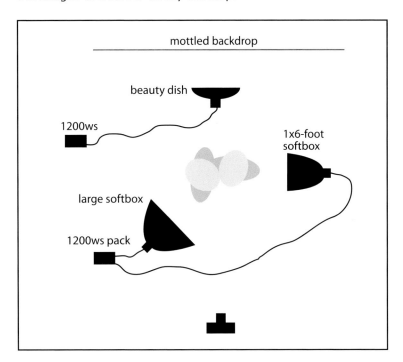

CASE STUDY 22

The Law

ASSIGNMENT

An ad agency in Missoula hired me to create brochure images for a 911 software company called Logisys. The art director was looking for four images showing the police department and a SWAT team doing their jobs. I had no idea what I was in for.

POSING AND LIGHTING

Lieutenant Pfau had limited time to be out on a photo shoot with a squad car, so the art director and I scouted (before the session) for a long stretch of road that had a rural appearance. I also took into account the time we would be shooting and the direction of light. I wanted the light to be behind my subject so I could use flash fill.

Once the time and place were determined, we scheduled a time for the officer to meet us. My only concern on this type of shoot is the ever-changing weather. My gear was pretty simple: a Hensel 1200ws Porto pack, a heavy-duty light stand, a sand bag, and a medium softbox.

The first light value I measured was the ambient back light, which was f/8.5 at $^1/_{90}$ second. Based on that, I set up my strobe light at a distance and power to illuminate the officer at f/6.7, almost a stop under the back light. This is a pretty straight-forward lighting technique but it's very effective and useful in many situations. The final step was to position the officer and tell him to look busy.

POSTPRODUCTION

After selecting the best images, in Lightroom's develop module I worked my way down the panels—starting with the exposure slider, where I opened up the image by about five points (making it brighter). In the color panel, I went through each color slider and either increased the luminance to brighten specific colors (like the yellow grass) or decreased the luminance to

PLANNING PAYS

This is a good example where planning pays off. Scouting the location (for a fee, of course) and taking into account all the potential problems ensured a successful shoot. By the time the officer was ready, I knew that all the other technical aspects of the shoot were covered so I could concentrate on working with him.

CAMERA DATA

Camera: Canon 30D
Aperture: f/8
Lens: 28–135mm at 60mm
Shutter speed: $^1/_{90}$ second
ISO: 100

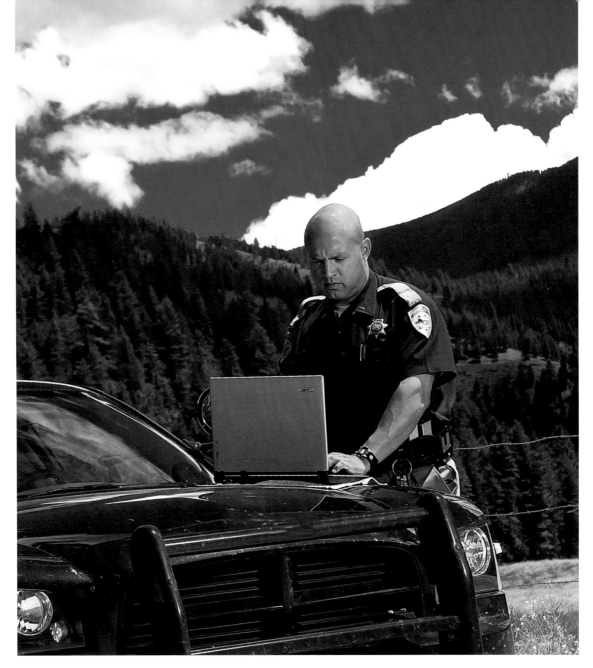

Sharpening the image.

darken them (like the blue sky). This powerful tool should be seriously considered when adjusting your images—but beware of overdoing it because the results may be too obvious. Next, I moved down to the detail panel and sharpened the image until it looked good. Again, too much sharpening can create problems so be sure to use the magnifier to closely examine the image detail.

Once the image looked good, I selected all the images and synchronized the adjustments. Then I exported the images to a

DVD as backup. The final step was to create a web gallery to send off to the client.

The image I selected looked pretty good—except for the fence post popping out of the officer's back. In Photoshop, I duplicated the background layer, then used the quick selection tool to select the post (since it was close to the officer). With the selection active, I used the very powerful spot healing brush (with the content-aware button selected) to draw out the post. I deactivated the selection and switched to a smaller brush to continue using the spot healing brush to draw out the barbed wire on the post.

There were few white marks on the hood of the car, and I used the clone stamp tool to eliminate those. Finally, I applied light sharpening using the unsharp mask filter. After flattening the image, I saved it as a PSD, TIFF, and high-resolution JPEG. I also planned to use this image on my web site, so I went to File> Save for Web & Devices to convert the image to be saved for on-line use.

Removing the post using the spot healing brush.

Saving the image for use on my web site.

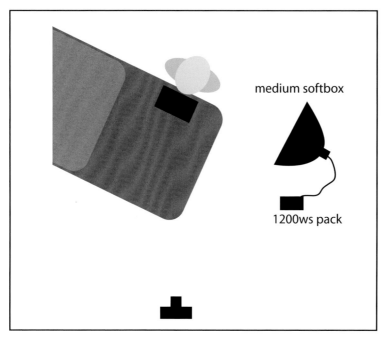

medium softbox

1200ws pack

Artificial Natural Light

ASSIGNMENT

One thing I neglected to mention in the previous case study is that we were on a tight budget. There were no professional models, no stylist, and no assistants, just a lot of helpful and friendly folks pulling together to create a brochure for a local company. If you look closely at the image on the next page, you will see that it's the same officer and the same computer from the previous image. In this case, I was asked to create a more quiet, indoor image.

POSE AND LIGHTING

I had scouted the 1908 courthouse a week before the shoot, looking for an interesting location for the "quiet" shot. I found this area—with marble walls, tiled floors, and original lighting—on the third floor. It seemed like a great location to mix modern technology with classic architecture. I wanted to make it look authentic, so I told Lt. Pfau to do some work on his computer and simply ignore me.

Because I was working solo, I pared down the amount of equipment I brought, carrying only my Hensel 1200ws pack, a couple of Canon 580EX flashes, and a tripod. This is where it got tricky. I wanted to make the shot look as though it were created with the existing light alone. To do this, I set up my main light to the far right of the camera on the other side of the rotunda. I used a 40-degree grid with a piece of diffuser over it. Then I placed a piece of black tape (about 2x2 inches) onto the dif-

NECESSITY

Necessity is truly the mother of invention. In this case, I was limited as to what I could bring to the set so I called on my speedlights, which are very light and can output a lot of light. They made a great companion to my portable strobe and really made the shot. I now carry my speedlights to all my shoots in addition to my strobes. A friend of mine who works for *National Geographic* uses only his speedlights and remotes when he travels.

CAMERA DATA

Camera: Canon 30D
Aperture: f/6.7
Lens: EF 24–105mm at 32mm
Shutter speed: $^1/_{15}$ second
ISO: 100

fuser to soften the light. I set it to expose the officer at f/6.7 (almost f/8). I then used a piece of black wrap to create a gobo that directed a shaft of light onto the floor.

I also needed to get some fill light—and I wanted to create an accent of light on the railing to lead the viewer into the shot. To do this, I pulled out my Canon flashes and put one on a Bogen Super Clamp, attached to the railing just out of frame. I set this flash to slave mode. I placed another flash on my camera and pointed it toward the ceiling. This was set as the master and put in manual mode. The flash

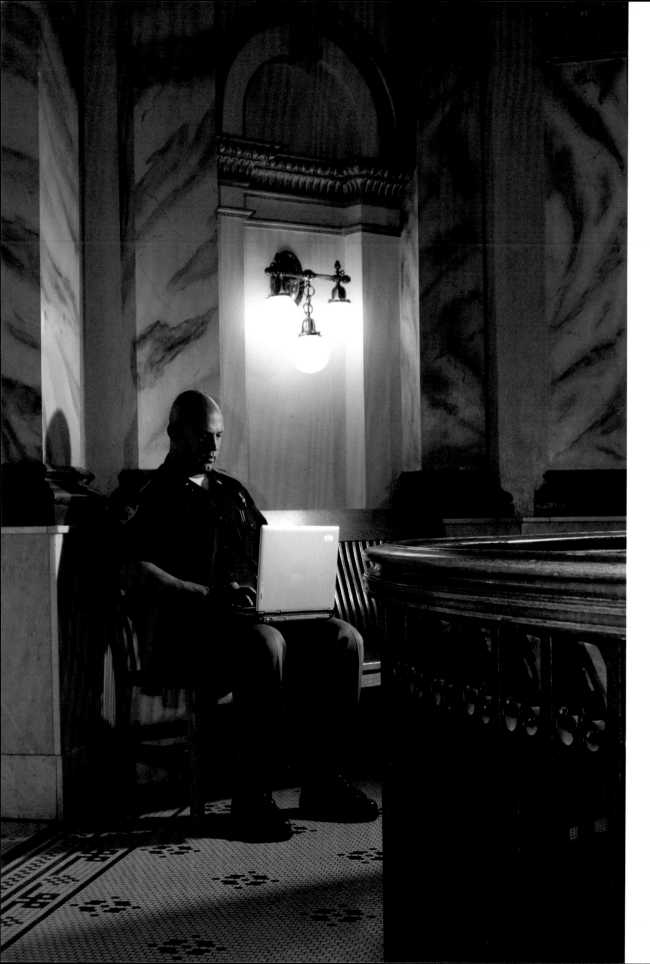

Adjusting color in Lightroom.

Checking levels in Photoshop.

on my camera triggered both the Speedlight and the Hensel, giving me the effect I wanted. The final step was to set my shutter speed to $^1/_{15}$ second (dragging the shutter) to pull in some ambient light and provide a more natural look. When doing this, using a cable release will help you avoid camera shake.

POSTPRODUCTION

I didn't need to shoot many frames of this setup, so it was an easy edit. After selecting and keywording the images, I went to Lightroom's develop module to cool the color in the photo. In the basic module, I moved the temperature slider to the left (blue) side. In the detail module, I sharpened the image. Finally, I synched all the images to these settings and created a web gallery for the client.

To further refine the image, I imported it to Photoshop, checked the levels, then duplicated the background layer. Using the clone stamp tool, I cleaned up the back of his computer. Then I selected the lights above his head using the quick selection tool. After expanding the selection by 4 pixels (Select>Modify>Expand), I used the curves to "dim" the lamps. I use this method a lot to tone down specular highlights. After some light sharpening with the unsharp mask filter, I flattened the image and saved it to a folder labeled "Logisys Picks."

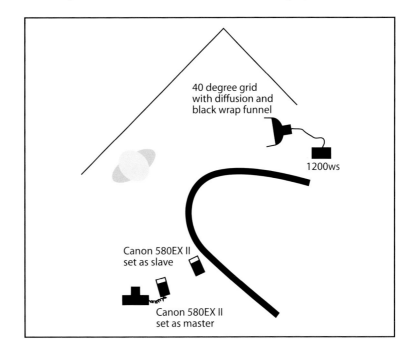

CASE STUDY 24

In the Room

ASSIGNMENT

Like the previous two case studies, this image was part of the Logisys shoot. For this shot, we wanted to show the control room at the company's headquarters. It was a bit of a lighting challenge—but a fun problem to solve.

POSING AND LIGHTING

My objective was to make the whole scene look natural. On a corporate shoot, this means finding out how the person does his/her work. After observing what they do, the key is to direct them so they look good but still seem to really be doing their job.

In this case, I had the subject turn toward the camera and pretend there was a screen in front of her. In reality, the monitors were all to her right side—but the pose looked good from the camera's perspective and that is all that matters.

The main light on the subject was a strobe, powered to f/5.6, bouncing off the ceiling. This was fitted with a black wrap gobo to prevent the light from hitting the computer monitors. Using a portable boom stand, I also placed a 30 degree grid behind the computers for accent light. The power of this light was set to f/8. Additionally, I placed black wrap on the bottom of this reflector to block the light from hitting the monitors.

For the final image, I turned off the lights in the room (including the modeling lights on the strobe), placed the camera on a tripod, and shot at f/5.6. I varied my shutter speed from $1/4$ second up to one second.

POSTPRODUCTION

Taking the images into Lightroom, I proceeded to edit my picks and assign keywords (woman, Logisys, blond, technician, computer, IT, etc.). I then exported the selected image onto a DVD and trashed the ones that were not selected. I created a web gallery from Lightroom and sent the images off to the client.

CORPORATE LOCATION SHOOTS

Here are two important tips for location portrait shoots: 1) ask questions and 2) observe the environment. By chatting with the person I'm photographing, I am able to learn what will create the best shot. I also study the environment carefully before I set up my lighting. In this case, I saw that light was coming from overhead lights and from the computer screens. For a realistic look, I used my strobe lights to duplicate what I saw, producing a high-quality, interesting image.

CAMERA DATA

Camera: Canon 30D
Aperture: f/16
Lens: EF 24–105mm at 28mm
Shutter speed: .3 seconds
ISO: 250

Stray hairs needed to be removed.

In Photoshop, I duplicated the background layer and began my work. Backlights can add a bit of drama to a photograph but they can also create a lot of extra retouching in the postproduction side. In this image, there were a lot of stray hairs. I selected the area I wanted to work on to avoid mishaps. I then chose the clone stamp tool to remove the hairs. I also wanted to get rid of her hair hanging down on the right side of her face. Using the same method, I carefully made the hair disappear.

I also decided to get rid of the cord behind the computer. I have found that the best way

I decided to remove the monitor's power cord.

I create and name a new layer as I make each edit, allowing me to track my work.

Removing hair visible on the right side of her face.

to keep track of all these changes is to du-
plicate each layer as I correct the image and
name it accordingly.

The client wanted to be sure that what was
on the computer screens was not legible in the
final images, so I selected the screens using
the polygonal lasso tool. I then applied the
Gaussian blur filter to obscure the writing on
the screens.

Finally, I flattened the image and saved it as
a TIFF, a high-resolution JPEG, and a JPEG for
on-line viewing.

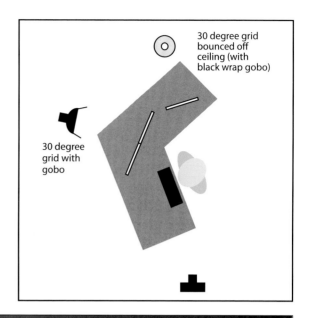

Original image (above) and
final image (right).

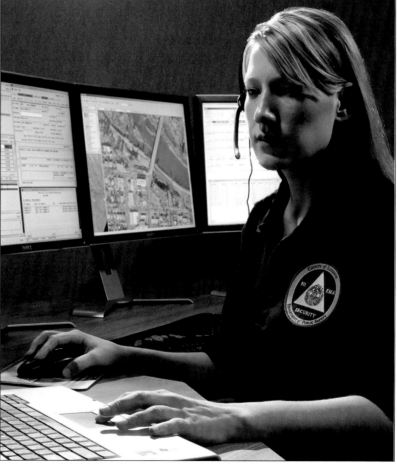

Dakota

MISS TEEN MONTANA

I've found the lighting setup used for this portrait to be very successful for public relations photos as well as headshots for actors and pageant contestants. The beauty dish is really perfect; since it evenly lights the face and creates no shadows, it almost gives off a glow. Obviously it worked for Dakota—she was crowned Miss Teen Montana in 2010!

CAMERA DATA

Camera: Canon 40D
Aperture: f/7.1
Lens: EF 24–105mm at 105mm
Shutter speed: $1/200$ second
ISO: 100

ASSIGNMENT

A friend of a friend had a daughter who was graduating from high school and needed a portrait. It turned out she was also entering the Miss Teen Montana pageant and needed a formal headshot for the event. To show me the standards, she sent me some samples of other pageant portraits to work from. Dakota came to the studio for a consultation and decided on her wardrobe and the look she wanted. I am happy to say she was crowned Miss Teen Montana—and it was all because of my photo! Okay, that's not true . . . but that kind of magical thinking *can* inspire success.

POSING AND LIGHTING

It is always easier to photograph someone who knows how to work with the camera. Dakota's experience with performing and auditioning gave her a good sense of how to pose for the camera. I gave her some direction, but for the most part she just "did her thing."

The lighting setup is one I often use for headshots. The main light is near the camera and the center axis is directed toward the subject's nose, which determines the height of the light. In this case, I used a beauty dish as the main light and clipped a white cotton bed sheet over it to reduce the power on Dakota to f/7. I placed a silver reflector (secured on a stand with an A-clamp) to camera right. I added a second silver reflector on a posing table below her, at about waist height, to open up the shadow area under her chin. For the hair light, I placed a 40 degree grid on a boom stand and set the exposure to f/8. For an even tone on the mottled gray background, I used two white umbrellas, placing one on each side of the set. The background was exposed at f/8.

I asked Dakota to smile, with her chin down, and think about what she had for breakfast.

POSTPRODUCTION

The shoot was very straightforward and, since we were working within the pageant's portrait guidelines, there weren't many options to try. As a result there also wasn't much to edit. Still, I went through my normal ritual of downloading the images into Lightroom, picking the final shots, assigning keywords and metadata, then creating a web gallery to send to the client.

Once the final photo was chosen, I exported it to Photoshop for some light retouching. I duplicated the background layer then checked the levels. I then removed a few stray hairs using the spot healing brush, setting the brush mode to normal and working with the content aware box checked. Next, I selected the teeth and used the hue/saturation function to gently desaturate and lighten the yellow cast my lights had created on them. Finally, I flattened the layers and applied light sharpening with the unsharp mask filter.

Setting the spot healing brush.

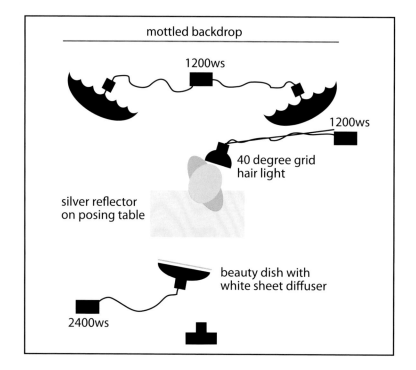

CASE STUDY 26

Dual Identity

ASSIGNMENT

After the success of our session for her Miss Teen Montana head shot, Dakota hired me to take her senior portrait. Unlike the pageant assignment, there were no rules—except that it had to be a vertical image for the yearbook. Over the years, I've learned that, even though we start with a studio session, the vast majority of seniors choose an environmental portrait for their final image. Dakota was no exception.

POSING AND LIGHTING

One of things I enjoy about photographing seniors is their awareness of how to look at the camera—it must be all the realty shows they watch. I make it a rule not to have the parents around during these shoots; this allows the seniors to be themselves.

For this image, I brought Dakota to my first location, the back of my studio building where there is a brick wall and a black metal staircase. I liked this image because of the juxtaposition of the hard brick wall and the soft subject.

Open shade is ideal for portraits—especially when you have a little help from a reflector and a speedlight. Here, I had Dakota lean and place her left hand on the railing. There was strong sunlight coming in from the left side of her face. To block this (letting just a little light filter onto her shoulder and hair as an accent), I added a silver reflector on a light stand to camera right. It was a still day, so I was able to secure this using two A clamps placed at the top and bottom.

This left me with light that was nice and even—but too flat for my taste. To add some dimension, I attached a speedlight (fitted with a Gary Fong diffuser for gentle softening) to a hotshoe cord and set my flash at half a stop below the ambient light level. I then put my camera on aperture priority mode at f/4 (for shallow focus). At this point, the flash and camera do all

NO LONGER DEADLY

In the past, I referred to electronic flash as the "third rail" of photography—a reference to the deadly, electrified third rail on the New York City subway. Today, however, these small lights have become so advanced and intuitive that they can be the photographer's best friend. Properly used, small flash can transform an ordinary portrait into an extraordinary one—with little postproduction required. That means you'll spend more time taking pictures and less time in front of your computer.

CAMERA DATA

Camera: Canon 40D
Aperture: f/7.1
Lens: EF 24–105mm at 65mm
Shutter speed: $1/80$ second
ISO: 100

the thinking for the correct exposure. I just held the flash above my head and directed it toward my subject.

POSTPRODUCTION

We shot at four different locations, so there were plenty of images to go through from this session. I selected about 25 percent of the shots for the client to review, then created a web gallery to send out. (*Note:* I do watermark all my images that go out to the client, placing the watermark across the subject.)

The image in this case study was exported to Photoshop for some minor retouching. I used the patch tool to eliminate a few stray hairs and some skin blemishes. I also used the burn tool (set to midtones) to darken the edges for a vignetted look. The final step was to sharpen the image. Because I handheld the camera and flash and shot at $1/80$ second, there was a little softness on her face. It was easily addressed by applying some light sharpening with the unsharp mask filter.

I then flattened the image and saved it as a TIFF and a high-resolution JPEG. I also converted the image for my web site using the File>Save for Web & Devices command.

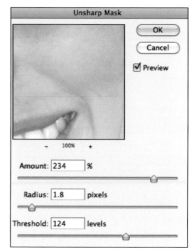

Applying the unsharp mask filter.

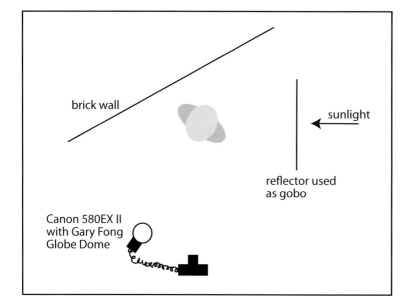

A Good Group

FILL FLASH

This is one of my favorite lighting setups, pairing one artificial light with the sun. Although you can darken the sky in Photoshop, simply syncing at a faster shutter speed (whatever your camera will allow) can do the same thing. Being old-school, I try to do as much in the camera as possible. As fun as Photoshop can be, I prefer to be out taking photos. For many outdoor situations this means simply adding fill flash. Having access to a powerful strobe and knowing how to use a light meter can give you a lot of creative options, especially when photographing a big group.

CAMERA DATA

Camera: Canon 40D
Aperture: f/7.1
Lens: EF 24–105mm at 47mm
Shutter speed: $^1/_{250}$ second
ISO: 100

ASSIGNMENT

One of the non-profit organizations I like to work with is the South Valley Child and Family Center (SVCFC). Before this assignment, I had created two images for their posters, one showing a mother and child, and one featuring a mother, father, and child. This time, the agency wanted to show a large group of children and the founder, Blaise Favara (his wife Faylee is the co-founder). The poster would be distributed around town with my credit line.

POSING AND LIGHTING

When the agency had told me the change of visual course for the photo, I suggested shooting in the backyard of my studio. I felt that the large, grassy hill would work well for the background—and if luck was on our side, it would be sunny.

The day came and it was partly sunny, a good sign. The kids arrived with the adults and, at first, I had them run down the hill holding onto the colorful fabric until they were worn out. This worked out well; when it came time to pose them with Blaise they were too tired to move around.

I wanted to build a pyramid of people, so I started with Blaise in a seated pose and surrounded him with children. I also added Claire and Mary, the owners of Belle Boutique (who held the fundraising fashion show). I had everyone lean in toward Blaise and placed Mary as the tip of the visual triangle.

Before I set up the shoot, I considered the time of day. I arranged the session for the early afternoon so everyone would be backlit, letting me use the sky as a giant hair light. I had my assistant climb up the hill and point the meter's dome toward the sun to measure the direct ambient light. The reading was f/11.5 at $^1/_{125}$ second.

Being on a low budget (*i.e.*, no budget), I could not set up a large scrim behind them on a boom stand to cut the backlight

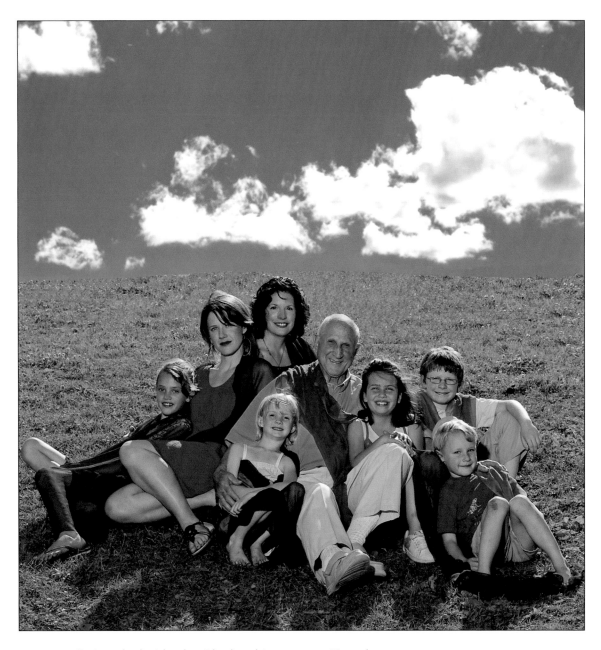

one stop. So I worked with what I had and I set up my Hensel 1200ws Porto pack on a light stand near the camera. I attached a sandbag to the legs to prevent it from falling over in case of strong wind. I knew I had to match the ambient light and still get enough coverage for the group, so I settled on a light reading of f/8. To get the sky darker, I took advantage of my camera's ability to synch with flash at up to $1/250$ second, which seemed to do the trick.

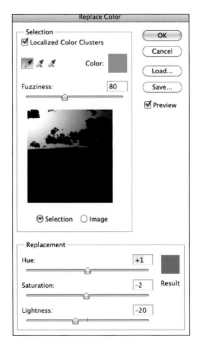

Replace color dialog box.

Choosing a brush for the clone stamp tool.

POSTPRODUCTION

After importing the images to Lightroom. I picked a few shots for the designer, then keyworded (children, SVCFV, Blaise, outdoors, etc.) the files. I sent the designer a web gallery and let them know I would clean up their selections in Photoshop and supply the final files via their FTP site.

After I imported this image, I duplicated the background layer and checked the levels. Everything looked good, but I felt the blue in the sky needed to be darker, so I went to Image>Adjustments>Replace Color. I then clicked on an area of the blue sky and adjusted the fuzziness slider to 80. I reduced the saturation to –2 and dropped the lightness setting to –20. Voilà—a darker blue sky!

The jagged shape of the hill top was another concern. It didn't quite do it for me, so I selected the polygonal lasso tool and drew a straight line across the hilltop and above. I then zoomed in on the hilltop and used the clone stamp tool to clean up the grass.

Finally, I flattened the image and saved it as a TIFF, a high-resolution JPEG, and a JPEG for my web site.

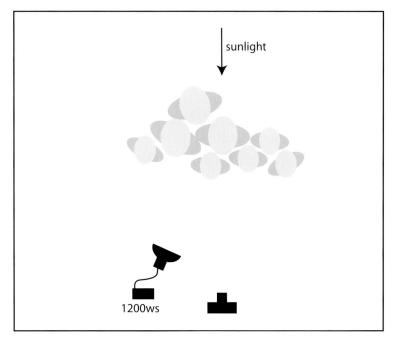

CASE STUDY 28

A Family Affair

ASSIGNMENT

To raise money for The Children's Museum, I donated a free portrait session for a silent auction. The family that won the silent auction wanted to get holiday shots, so we scheduled a session about a month before the holidays.

POSING AND LIGHTING

When the Hart family arrived at my studio, they cautioned me that they were not sure how long their daughter would be able sit still. Based on that, I decided to photograph the family group first and see how it went from there. I had the father anchor himself on a posing stool and placed the mother behind him. I then asked her to wrap her arms around everyone to keep them together. The strategy worked and I was able to shoot quite a few frames before the daughter became restless.

Melissa, like her daughter, had great hair. I wanted to use that attribute to frame the shot, so I asked her to bring her hair over her right shoulder and tilt her head to her right.

The lighting was all set up before they arrived (of course). After I set up a black background, I applied my basic portrait lighting strategy. I started with the main light, a large softbox placed to the left of my camera and about six feet high at the center. I set that light at f/7 and based my settings for the other lights on that reading. The next lights I placed were two 1x6-foot softboxes, positioned on each side of the subjects and set to f/8. Finally, I added a beauty dish as the hair light. I set that light for f/8.

POSTPRODUCTION

After downloading my images into Lightroom, I made my picks and exported the chosen images onto a DVD. I selected all the picked images and created a web gallery to send to the client.

NON-PROFITS

As a professional photographer, is it a good idea to donate your services? It depends. The Children's Museum is a non-profit place for families to go and play and learn. In addition to supporting that worthwhile cause by donating a session to the auction, I was willing to bet that the winning family would tell their friends about my services and order additional prints. As altruistic as you may be, photography is first and foremost a business. Your decision to donate should be made from a business perspective.

CAMERA DATA

Camera: Canon 40D
Aperture: f/7.1
Lens: EF 24–105mm at 80mm
Shutter speed: $^1/_{100}$ second
ISO: 100

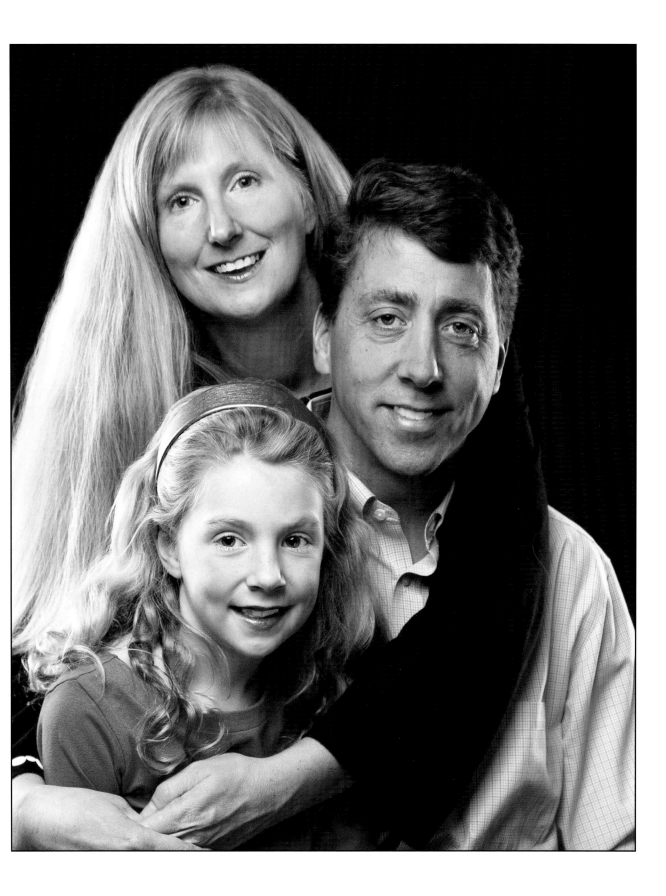

In my e-mail to them, I noted the deadline dates for any print orders they wanted to have back in time for Christmas.

The image they chose happens to be one of my favorites—and the one in this book. There was little retouching to be done. After tweaking the levels in Photoshop, I duplicated the background layer. I then selected the areas where I wanted to work and used the clone stamp tool to get rid of a few stray hairs. Next, I made another duplicate layer and selected the teeth. Using the hue/saturation function, I reduced the saturation (making the teeth closer to white) and increased the lightness to subtly brighten the family's smiles. I then flattened the image and applied light sharpening using the unsharp mask filter.

Finally, I saved the image as a high-resolution JPEG and placed it on my desktop in a folder labeled "prints to order from WHCC."

Reducing the saturation and increasing the lightness to whiten the teeth.

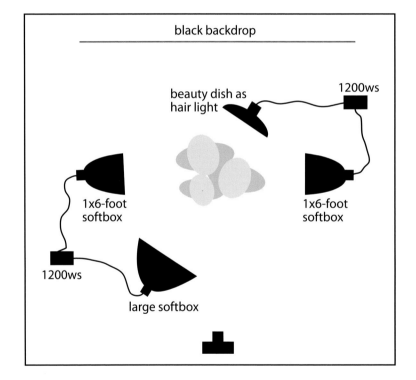

Faux Fun

ASSIGNMENT

I got a call from a designer who was putting together a brochure for an artist who specializes in creating faux finishes. The majority of the work was creating architectural images and detail shots of the finishes. However, they also wanted a portrait of Jill Meyer, the owner of the company. The house we shot in was newly built and designed in the Italian Renaissance style— with plenty of columns, sconces, and even a sunken living room. Jill's job was to marbleize and texture the walls. My job was to photograph the treatments and Jill herself.

POSING AND LIGHTING

The portrait of Jill was the last shot of the day, which gave me some time to think about where I wanted to place her. It made sense to me to have her leaning against one of the columns, showing off some of the detail her work brought to the architectural style. She was wearing a satin blouse, which I thought worked well against hard surfaces. Having her lean back onto the column (I had her move her feet slightly away from it) and place her hands on her hips created a casual and inviting style.

Since color accuracy was paramount, I took an initial test shot with my Macbeth Color Checker in the frame. I then placed a medium softbox to the left of the camera, setting it about six feet high and tilting it down. This was positioned as close as I could get it to my subject without allowing it to intrude into the frame. This light was set at f/11 to pick up as much detail as possible in the wall treatment. I then placed a silver reflector to camera right to add some fill. I placed another medium softbox behind the column, directing it toward my subject. I set the power on this box to f/16 to produce an accent light on the column and her arm. To illuminate the background I bounced a strobe (with the reflector on) off the white ceiling and set the exposure to f/8.

POSTPRODUCTION

After I picked my favorite images, I burned them onto a DVD and created a web gallery. I sent this to the designer so she could select the shots for the brochure.

RELATIONSHIPS

Building client relationships is critical to sustaining your business. On this shoot, I developed a bond with the designer's client, who stayed throughout the shoot. Jill contacted me a year later with another project in mind. Later, her business partner hired me to do her son's senior portrait. We continue to do projects together—and sometimes even barter our skills.

CAMERA DATA

Camera: Canon 30D
Aperture: f/11
Lens: EF 24–105mm at 75mm
Shutter speed: $1/30$ second
ISO: 100

The image of Jill was edited in Photoshop. The first thing I did was create a duplicate background layer. Then I took a few moments to study the image carefully, determining what I could do to make the subject and the scene each look their very best.

I decided to thin out her waist a little. To do this, I selected her torso using the lasso tool. With this selection active, I went to Edit>Transform>Warp. Using the grid that appeared, I grabbed and moved some of the intersection points to slim my subject. (*Note:* This is a great technique to thin out arms, get rid of double chins, and eliminate muffin tops.) Once I was happy with the shape, I applied the transformation. After the change took place, however, some parts of her shirt remained that were disconnected from her body. I used the clone stamp tool to get rid of any "residue" from the transformation.

The other thing that bothered me was the tilting of the columns. To eliminate this, I created another duplicate layer and selected the entire image using the Cmd+A keyboard shortcut. I then placed a grid over the image using the Cmd+' shortcut. Finally, I went to Edit>Transform>Skew. On the grid that appeared, I grabbed the upper left corner and pulled it in to the right. I then cropped the image to remove the gap this created. You could also use the clone stamp tool to fill in the gap.

To add a little softness to Jill's look, I went to Filter>Blur>Surface Blur and set the radius at 55 and the threshold at 7 levels.

Finally, I flattened the image and saved it as both a TIFF and a high-resolution JPEG. When the images were complete, I burned them to a DVD and sent it to the client.

Removing background distortion.

Original image.

Thinning the waist.

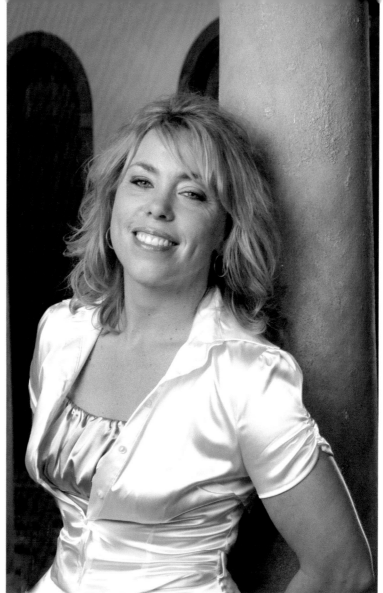

Original image (above) and final image (right).

Applying the surface blur filter.

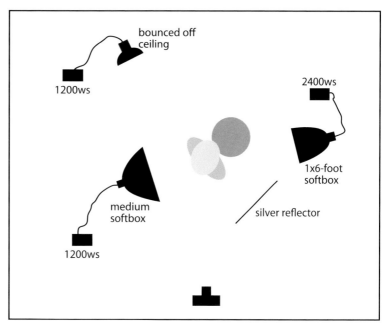

CASE STUDY 30

Mother and Child

ASSIGNMENT

As a portrait photographer, you often encounter happy accidents. In this case, I was setting up for the mother-and-child portrait with a totally different concept in mind. As I was posing them, I shot some images along the way—and this is one.

POSING AND LIGHTING

This moment happened because I make it a habit to maintain a dialogue with the client from the beginning to the end of the session. With all your planning and inner voice telling you what to shoot, it is often the natural, "in between" moments that truly capture the spirit of your subject. In this case, I was directing Claire and Erin so I could see how the light looked and check the fan speed. As you can see, they were both listening.

I used three lights to create this image. The main light was an extreme sidelight that was modified with a Profoto Globe and set at f/11. The backlight was a Profoto Wide Zoom Reflector with a 40 degree grid set at f/16. This was mounted on a portable boom stand. I then set up a bare tube light behind them. I taped some black wrap on the backside of this strobe to block it from hitting the background. I really wanted to blast some light into their hair, so I set that at f/22.

DON'T TOSS YOUR FILES

There is a famous image of President Bill Clinton and Monica Lewinsky hugging at a large rally. If that photographer had been shooting digital, he probably would have deleted the "meaningless" image—end of story. It's a good lesson not to be too quick to toss your files. It may take a little more time and labor to import them for viewing on a bigger screen, but it gives you a chance to save the ones *you* like, not just the ones you think your client will pick. You can waste a lot of precious time looking at the back of your camera rather than *through* it.

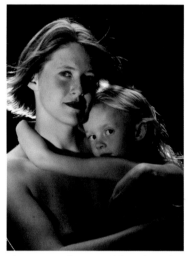

The original image (above) and the final image (facing page).

CAMERA DATA

Camera: Canon 30D
Aperture: f/11
Lens: EF 24–105mm at 105mm
Shutter speed: $^1/_{125}$ second
ISO: 100

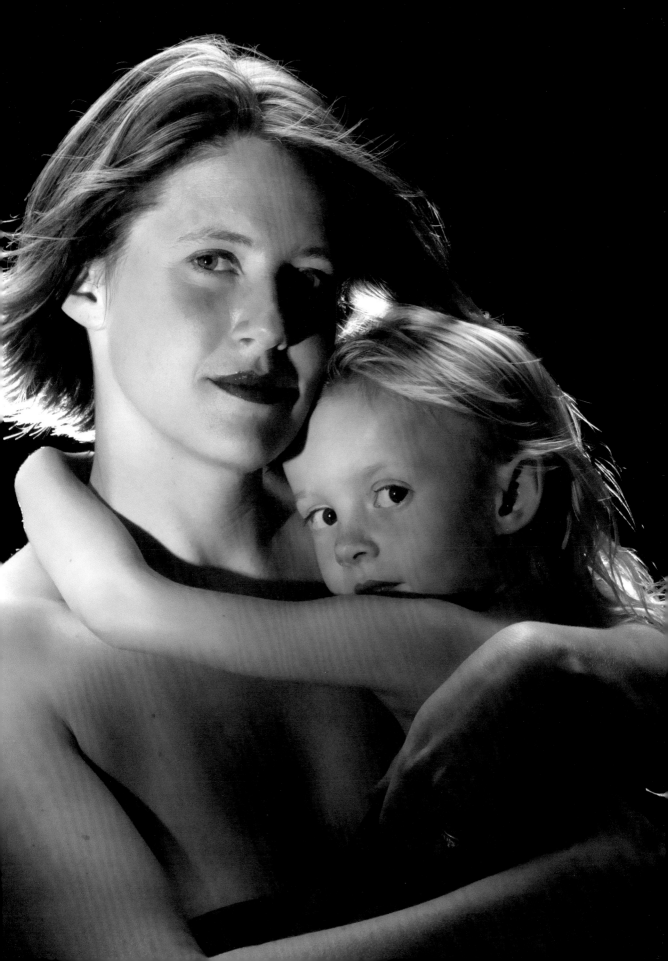

POSTPRODUCTION

After importing the images to Lightroom, I placed one star on images for the client and two stars on images for me. The client had a very specific idea in mind; I just liked the entire shoot. I then filtered down to the one-star images and created a web gallery for the client. As I was putting this book together, however, I came across this image and found it still tugged at me.

To refine the shot, I imported it into Photoshop, duplicated the background layer, and adjusted the levels.

I felt her lips were a little too red for the natural feel of the image, so I used the quick selection tool to select the lips. With the refine edge dialog box I was able to quickly fine-tune the selection. Going to Image>Adjust>Hue/Saturation, I reduced the saturation setting to tone down her lips. I completed the retouching by using the spot healing brush (with the content aware option active) to remove some blemishes and stray hairs.

To soften the skin and make the image more ethereal I applied the surface blur filter. I then flattened the image and saved it as a TIFF, a high-resolution JPEG, and a JPEG for my web site.

Refining the selection edge.

Reducing the saturation.

Applying the surface blur filter.

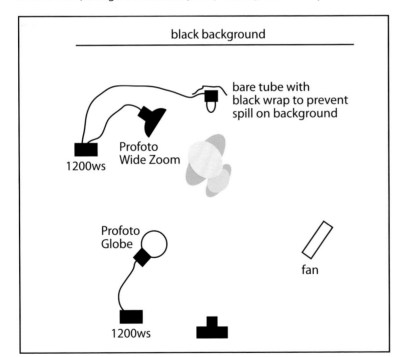

My Day in Butte

ASSIGNMENT

I don't often accept an assignment to travel two hours to shoot a high school senior portrait—but when a good client, and friend, told me about their "amazing friend in Butte, Montana" who "really liked my work and wanted me to take her senior portrait," how could I say no? We worked out the expenses and I booked a photo date with Lew Yong.

Butte has an infamous history as home of the Copper Kings and Anaconda Mining Company. The result is an intriguing landscape; it's a once-rich city turned industrial wasteland with ornate mansions and a diverse population. I thought Butte, and especially the abandoned mining rigs, would be a great backdrop for a portrait. When Lew Yong suggested a portrait at the historical mining site, I was stoked.

POSING AND LIGHTING

When we arrived at the site, my assistant and I scouted around for "the shot." There was a lot to choose from, but my objective was to find a location that would compliment Lew Yong—a pretty, athletic teenager who wanted cool-looking senior portraits showing off her environment. I found this site at one of the abandoned rigs and felt it would be a great juxtaposition.

I positioned Lew Yong so that her back was to the scarce sun, hoping it would contribute a little backlight. To make her "pop" out I had my assistant hold a speedlight to camera-left. In shutter priority mode (Tv), I set the shutter speed to $1/250$ second, underexposing the ambient light by one stop. I set my flash to +1EV for a proper exposure of Lew Yong. To soften the flash, I added a Gary Fong flash modifier.

At first, I had Lew Yong stand—but the pose, while epic-looking, didn't seem to capture her playful personality. I realized I was too focused on capturing the backdrop, so I had Lew Yong sit so that she would fill the frame. I asked her to place her hand under her chin, put her knees together, and smile. The wind started picking up, her hair was blowing back, and the sun even popped out a little. As I continued shooting, I asked Lew Yong to close her eyes, take some deep breaths, and on the count of three open her eyes and smile.

STAYING ON TASK

This was fun shoot and I am happy to say the client was pleased. During this session, I was reminded how important it is not to let my preconceived ideas get the best of me. I was so determined to get a dynamic shot of the environment that I almost forgot why I was there— to create some great shots of Lew Yong.

CAMERA DATA

Camera: Canon 7D
Aperture: f/5.6
Lens: EF 28–70mm at 38mm
Shutter speed: $1/250$ second
ISO: 100

POSTPRODUCTION

I imported the images into Lightroom and proceeded with my with normal editing routine—selecting images, archiving them to DVD, and sending a web gallery to Lew Yong.

For this case study, I chose an image I liked and copied it to my desktop to import into Lightroom 4 still in beta as of this writing).

In the develop module, I started with the basic panel, checking the clipping indicators to see if I needed to bring back detail in the highlights or shadows. I saw that the clouds were a bit blown out (as indicated by the red color), so I moved the highlight slider to –49.

Red areas indicate blown-out highlights.

From there, I moved onto a new feature in Lightroom 4: whites and blacks. I wanted the sky to look a little stormier so I slid the whites slider to –49, darkening the sky but not my subject—pretty cool! To create a little more contrast, I moved the shadows slider to –9 and increased the blacks slider to +7.

Turning to the presence panel, I increased the clarity to +33 for sharpening (here, Lightroom 4 offers a big improvement over Lightroom 3, eliminating the artifacts that would appear when setting the clarity too high). I adjusted the vibrance to +20 to warm the color.

In the tonal curve panel, Lightroom 4 adds the option to switch from a parametric curve to a point curve. This allows you to control the color channels (just like in Photoshop). In this case, I adjusted the red channel, pulling the line down to reduce the red cast in the image.

After some subtle tweaks in the HSL/color/B&W panel, I moved down to the detail panel, which seems a little more robust than Lightroom 3. I especially like the noise reduction control; when you pump it up, it has a similar effect to the surface blur filter in Photoshop.

My final stop was the effect panel. I switched to the paint overlay style and moved the slider around until I liked what I saw.

At this point, it was time to make some local changes so I exported the image to Photoshop, making sure to include the Lightroom adjustments.

Exporting from Lightroom to Photoshop.

In Photoshop, I duplicated the background layer and worked on cleaning up some skin blemishes using the spot healing tool. With a soft brush, I also blended the color of her lips, using a sampled color.

I didn't want her bra straps to show, so I use the quick selection tool to choose them. I expanded the selection by 5 pixels (Select>Modify>Expand), then applied content aware fill (Edit>Fill>Content Aware) to make the straps disappear. To complete the retouching in this area, I sampled a nearby area of her skin with the eyedropper tool, then used a

Removing the bra straps.

soft brush to blend in the color of the shoulder where the straps were.

When I stepped back and looked at the overall image, I liked that her hair was blowing around and not perfect—but it felt too dark. With the dodge tool and set to shadow and 50 percent exposure, I lightened it slightly.

I then flattened the image and saved it as a TIFF, a high-resolution JPEG, and a JPEG for on-line viewing—and called it a day!

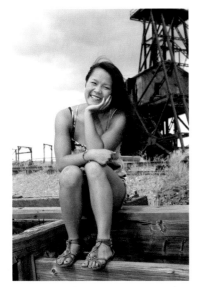

The original image (above) and the final image (right).

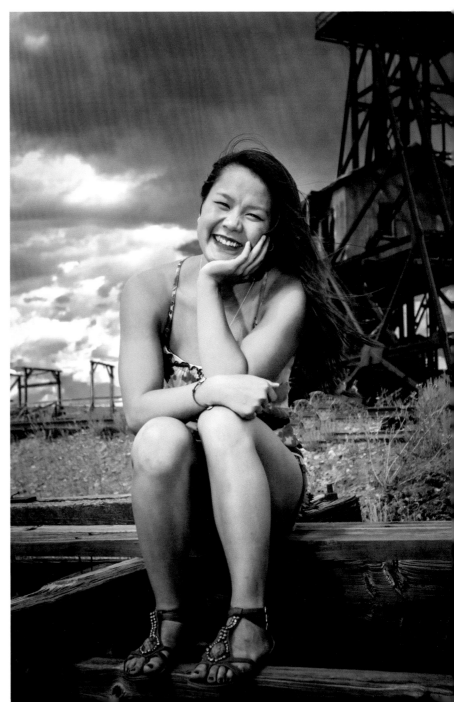

CASE STUDY 32

Gary and Judy

ASSIGNMENT

A former student of mine decided to give some friends a special anniversary present: a portrait session. What a great idea! Gary and Judy lived in Portland and were coming to Missoula for a graduation, which determined the date of our session. Since we were not going to meet

RETOUCHING

Here are two important things I have learned about retouching. First, ask your client how far you can go with the cleanup. The client may be proud of their moles, warts, scars, etc. (I have found that men usually don't care and women do.) Second, don't go overboard unless you are creating a character for a science-fiction movie. I can't tell you how many times I hear parents of seniors say, "Please make my kid look like my kid." In addition to the fact that people don't want to look over-retouched, spending too much time retouching costs you money. The more time you spend shooting images, the more likely you will be earning a profit. (And if a client requests extensive digital changes, make sure you bill appropriately; good photo retouchers get $80 to $160 an hour.)

CAMERA DATA

Camera: Canon 7D
Aperture: f/13
Lens: EF 24–105mm at 84mm
Shutter speed: $^1/_{125}$ second
ISO: 100

before the shoot, I asked them to bring several changes of wardrobe and happy faces. When they arrived at my studio, we chatted a bit, went through their wardrobe, and made a plan of action. I was glad to see the color of the wardrobe they brought; Gary's black shirt was classic and Judy's turquoise jacket and blouse complemented it nicely.

POSING AND LIGHTING

I had Gary sit on a tall posing stool, while Judy sat on a smaller one. Judy leaned back into Gary, and I asked Gary to wrap his hands around Judy. I adjusted the pose until it felt and looked right. I then asked Judy to reach up with her left hand to grab Gary's right hand.

I had them both to close their eyes and open them up when I got to a count of three. We did this several times, but I felt there wasn't enough spontaneity. So I modified the request; when I got to three, I asked Gary to pull Judy toward him as they opened their eyes. This changed the dynamic of image and brought a natural smile to Judy's face.

Until the subjects arrived, I wasn't sure whether I was going to shoot full-length or waist-up portraits, so I placed a large softbox to camera right to ensure sufficient coverage. I set the main light to f/13 at $^1/_{125}$ second. I then added a 1x6-foot softbox to camera left to separate Gary's black shirt from the background. This was set to f/16. On a boom stand behind them, I placed a beauty dish as a hair

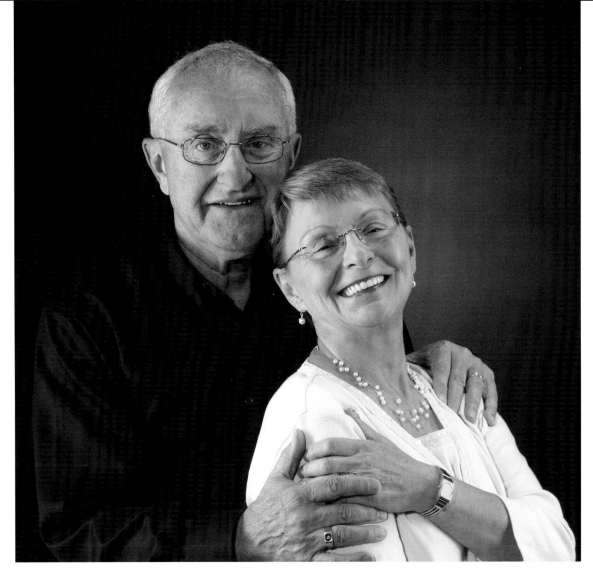

Gary and Judy's web gallery.

light. Since they both had gray hair, I kept the hair light at the same power as the main light (f/13) so it wasn't too obvious.

POSTPRODUCTION

After importing the images into Lightroom, I picked my favorites and created a web gallery to send out to Judy and Gary.

My favorite image needed a little work, so I moved it to Photoshop and duplicated the background layer. Using the levels, I contracted the histogram a little to brighten up the image.

I created another layer to remove the highlights from Judy's glasses. There are many ways to do this, but I like to use the patch tool. To do this, you simply surround the white highlight with the patch tool, then drag to a nearby area with the correct replacement tone. Poof! It's gone.

In most cases, I like to subtly brighten the teeth—just so clients don't look at their images and think, "Gee, I wish my teeth were whiter." In this case, I used the quick selection tool to select the teeth and zoomed in close on the area so I could clearly see what I was doing and make the adjustments precisely. With the selection active, I went to Image>Adjustments>Hue/Saturation, where I gently reduced the saturation and increased the lightness. Too much change will look unnatural.

I had asked the clients how much retouching they wanted, and Judy basically gave me carte blanche—so I went to work. Using the patch tool, I removed the lines under her chin and forehead. I also removed a vertical worry line on Gary's forehead. I then used the blur tool to smooth out the lines under her eyes. Because the lenses in her glasses were tinted, they darkened her eyes. To remedy this, I used the dodge tool. The last item that bothered me was her highly reflective watch; I selected it and used the curves command (pulling down on the right side of the curve) to darken it to a shade of gray that was much less eye-catching in the final portrait.

At this point, everything looked good, so I flattened the image and saved it as a TIFF, a high-resolution JPEG, and a JPEG for my web site.

I removed the highlights on Judy's glasses using the patch tool.

The teeth before and after.

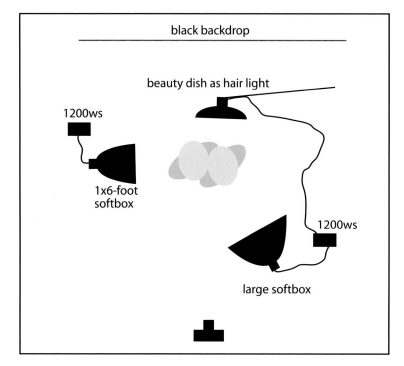

black backdrop

beauty dish as hair light

1200ws

1x6-foot softbox

1200ws

large softbox

New Paradise Laboratories

ASSIGNMENT

I was asked by New Paradise Laboratories, a theater group, to create an image to promote their next show, *Rose Selavy Takes a Lover in Philadelphia.* I had worked with the director before, so I knew that the shoot would be a truly collaborative and organic process. Additionally, the theatrical piece was not complete, so the image evolved throughout the session.

POSING AND LIGHTING

The concept was to create, all in-camera, the look of a Marc Chagall tapestry. We wanted to show bodies floating in all directions—but also to infuse each character with a story.

As a framework for posing, we constructed a metal scaffold and brought in fabric to drape around the scaffold and the actors. Behind them was a mirror, complicating the matter even more. Behind the camera, I placed a red trunk on a box and draped the box with black fabric to make it appear as if it were floating.

Once all the inanimate objects were in place, we brought in the actors and placed them accordingly. The director of the production, Whit MacLaughlin, gave them directions and I set the lights once everyone was in place.

I wanted to create a theatrical look using the lighting, but I also needed to avoid revealing the lights themselves in the mirror I was shooting into. To accomplish this, I set up a large softbox to throw an overall level of gen-

eral lighting onto the scene. This was powered to f/11. I also wanted a little blur, so I set up a couple of hot lights and directed them toward the actors. I metered the hot lights and found that I had to set my shutter speed to ¹/₄ second to read f/11, matching the strobe light. I did not gel the tungsten light, knowing it would

LOOK, MA—NO PHOTOSHOP!

I chose this image to demonstrate that Photoshop does not *always* have to be in the mix. I come from a generation of photographers who learned how to create images in-camera—with smoke and mirrors, if necessary. I still believe that if a photographer can see something in his mind's eye and create it the camera, he will produce imaginative work. I also know that if you go into a shoot not relying on software to fix your mistakes, you will become a more competent and reliable photographer. Give it a try. Next time you're shooting, try covering the LCD until you're done. Force yourself to think and stay in the moment! I just got back from a wedding where I was a guest and can't tell you how many shots were missed because the photographer looked at his LCD after every capture.

CAMERA DATA

Camera: Canon 20D
Aperture: f/11
Lens: 28–135mm at 38mm
Shutter speed: ¹/₄ second
ISO: 100

add a sense of warmth to the image—another way of giving the shot a more theatrical look.

I then directed a medium softbox toward the lid of the red trunk. This was powered to f/16, creating a hot spot that would frame the flowers. I also placed a bare flash head inside the trunk to give it depth.

I realized I needed one more light to create separation between the actors furthest away from the camera and the mirrored background; we needed to be able to see their backs in the mirror. To address this, I set up a medium softbox, directing it toward their backs. I powered the strobe to f/11. Phew!

Setting the camera on a tripod, I locked up the mirror to avoid camera shake and used a cable release. I began shooting at ¼ second as we asked the actors to get into their roles.

I also placed a bare flash head inside the trunk to give it depth.

POSTPRODUCTION

I imported the images into Lightroom and made my selections. I burned them onto a CD for Whit to review, deciding which one worked best to promote the play. That's all she wrote!

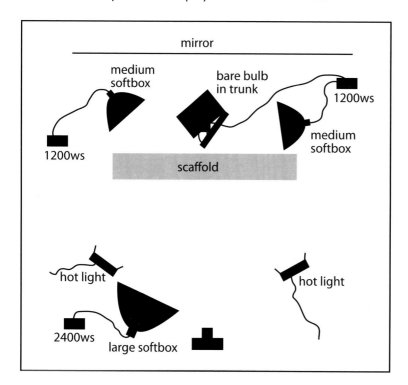

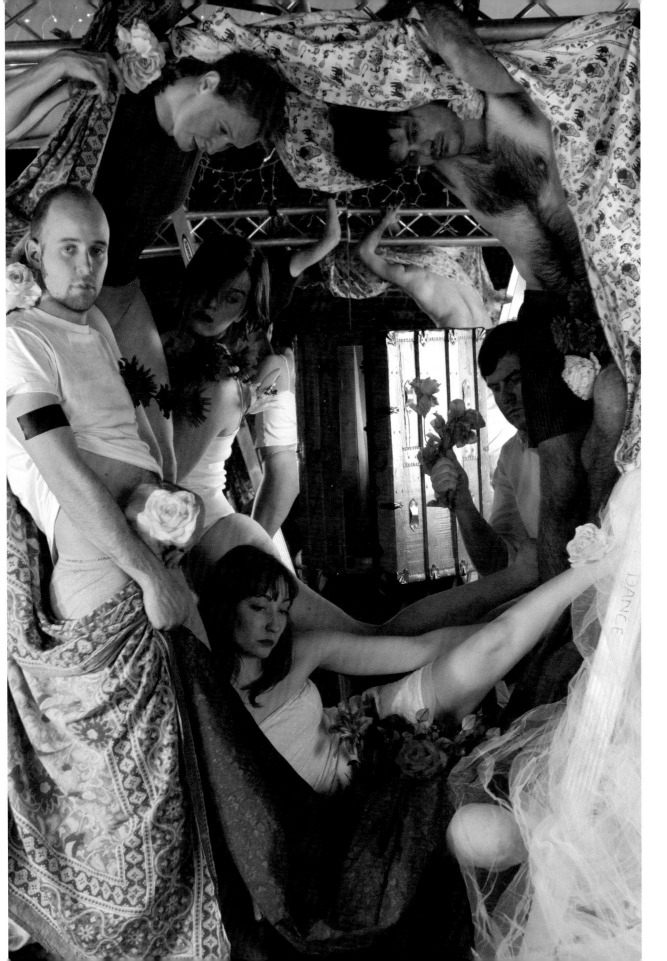

CASE STUDY 34

Corporate Shift

ASSIGNMENT

A local agency called me about taking architectural and landscape images for the Missoula-based company WGM. The partners also needed a portrait to send off to a magazine that was doing an article about the company. I went to their offices and scouted around for a site that would make sense and not disrupt their work day. I was looking for an office space that had some personality and showed off what they did.

LIGHTING AND POSING

The room I chose was not very big, but it had the right look and feel. Fortunately, I'm used to working in small spaces—my first studio in Manhattan was a shared space of just 700 sq. feet. For many sessions, I would literally hang out the window to get far enough back to photograph my subjects!

My objective was to re-create the room's window light. To do this, I set up a medium softbox in front of the window and powered up the strobe to f/11. Knowing that the light would fall off behind them, I set up an additional strobe with a reflector to bounce off the low white ceiling, visually extending the reach of the main light. That strobe also metered f/11.

Once I was happy with the way the room was lit, I started arranging the furniture and hanging charts on the walls. I set up the mission-style chairs around the table and waited to see who would be sitting and standing until I brought in my subjects—Nick, Brent, and Kristin. Because Brent was the shortest of the three subjects, I decided that having him standing would produce a tighter composition, keeping their faces close together.

I started shooting from different perspectives, looking down, straight on, and from low angles. My favorite turned out to be from a low angle. I liked the lower angle because it showed off the design of the chairs. In addition, the corner of the desk helps draw your eye toward the subjects.

SUBTLE EFFECTS

This image is a good example of how Photoshop can be used effectively—without seeming over the top. If you did not see the original image, I doubt you would even notice the changes I made to this image. A good understanding of the basics of photography—depth of field, shutter speed, and even the keystone effect—can help you make intelligent choices as to which Photoshop tool to use for the most seamless result.

Original image (above) and final image (facing page).

To pose the hands, I had Nick hold his glasses and Kristin do the classic hand-over-hand pose. Brent used the table as a support and I had him put his right hand in his pants pocket to be more casual.

POSTPRODUCTION

After downloading the images to Lightroom, making my selections, and adding keywords, I burned the selected images to DVD.

I shot with enough depth of field to be sure all three subjects were in focus. Because the room was so small, however, this also resulted the background being in focus. I found this somewhat distracting.

In Photoshop, I duplicated the background layer and checked the levels. After selecting the yellow frame behind Kristin's head, I used the clone stamp tool to make it disappear. The paper on the table was also too bright, so I

Removing a background distraction.

Applying the lens blur filter.

The layers palette.

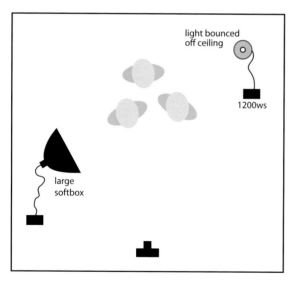

CAMERA DATA

Camera: Canon 40D
Aperture: f/11
Lens: EF 24–105mm at 24mm
Shutter speed: $^1/_{125}$ second
ISO: 100

selected it using the magic wand, then used the curves to bring it down to a light gray value that was less distracting.

After creating another duplicate layer, I used the quick selection tool to isolate the background and foreground (the table corner). I went to Filter>Blur>Lens Blur to add just enough blur to keep the attention on the three people, not the foreground or background. It looked good to me so I flattened the image and saved it as a TIFF, high-resolution JPEG, and JPEG for web and devices.

Fabulous Fightin' Family

ASSIGNMENT

After enrolling our son at the Missoula Tae Kwon Do Center, I took him to the practices and was happy to observe the discipline and life lessons taught in the class—and glad to see there was lot of fun going on, too.

I decided to ask the owners, Steve and Amanda, if they were interested in having me come in to shoot portraits of the students (for a fee, of course). They were hosting a "Family Field Day" and expected 150 students and parents to come for a workout. When they showed me a photo they had done the previous year of all 150 participants in a line-up fashion, I quickly realized I could provide a valuable service. They also cautioned me that, because the previous photographer had charged a lot and provided mediocre images, this year's participants might be reluctant to purchase prints.

LIGHTING AND POSING

Thinking about the white *doboks* (uniforms) they would be wearing and the colorful *dhees* (belts), I decided to set up a large 20x30-foot black cloth background. I was also excited to include the red mat on the floor.

Knowing I was going to shoot individuals and groups of different sizes (kids as young as five and groups of up to thirty people), I knew I needed a flexible, general lighting setup. I set up four softboxes, two on each side of the where the subjects would be standing. I also set up a light with a 40 degree grid in the back as an accent/hair light to make sure there was

The lighting setup.

sufficient separation for dark hair from the background. (Light hair was not a problem.)

I set the power of all the main lights so they would read f/10. The hair light was powered up to f/14. As the individuals and groups came in, I just made minor adjustments in the height of the lights to accommodate their height and the size of the group.

For the image of the Rosbarsky family, shown in this case study, I lowered the front camera-left softbox to light the children in the foreground and moved the hair light to highlight the dad's dark hair. The *poomse* (pose) was *choon bi* (the ready position). It makes my job easy when the pose is already set!

CAMERA DATA

Camera: Canon 7D
Aperture: f/10
Lens: 24–70mm at 45mm
Shutter speed: $^1/_{200}$ second
ISO: 100

POSTPRODUCTION

When I do this type of school photography, I shoot all the images as high-quality JPEGs, not RAW files. Given the large quantity of images, shooting in JPEG saves on time and memory space. And since the final image is small (usually a 5x7-inch print, not a billboard), the quality is fine.

After the images from this session were imported, I selected my favorites, added keywords, and applied the copyright metadata before burning them to a DVD.

The image of the Rosbarsky family did not need much postproduction work, but I imported it into Photoshop for a minor retouch. Once imported, I created a duplicate layer and adjusted the levels. Then I scanned the image with the magnifier tool and decided to get rid of a white label on the girl's belt. I used the lasso tool to select the label and then applied the clone stamp tool to make it disappear.

I then flattened the image and saved it as Rosbarskyfam.JPEG and placed it in a folder on my desktop labeled "MTCprints to order." Once I had all the images cleaned up and ready to export, I uploaded them to Pictage so families could order additional prints.

SCHOOL PHOTOGRAPHY

When I moved to a small town, I never thought I would be photographing schools and groups. However, I kept in mind the story of the great photographer Herb Ritts, who said that his best training came as a school photographer in California—when he had to produce good images on demand, every day.

I started in school photography because my children were going to a small school that needed a class portrait and student photos. (Large school photo agencies can't service small schools because of the profit margin.) As it turned out, it was fun for me—and I got to know the teachers, students, and other parents in the community.

It also gave me some training in the logistics required to take on other school-type photo assignments, such as this one at the Tae Kwon Do Center. It is not the big money I would receive from corporate clients, but it's more than I'd bring in on a one-day editorial assignment—plus, these jobs help expand my local client base.

If you want to sustain your photography business, it's good to keep all your options open. (Another well-known photographer, Barbara Bordnick, put it well, suggesting that you should avoid turning down assignments, because you never know where they might lead.)

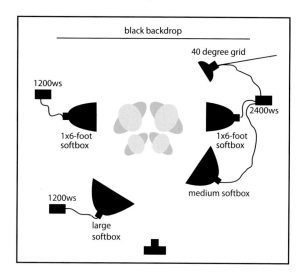

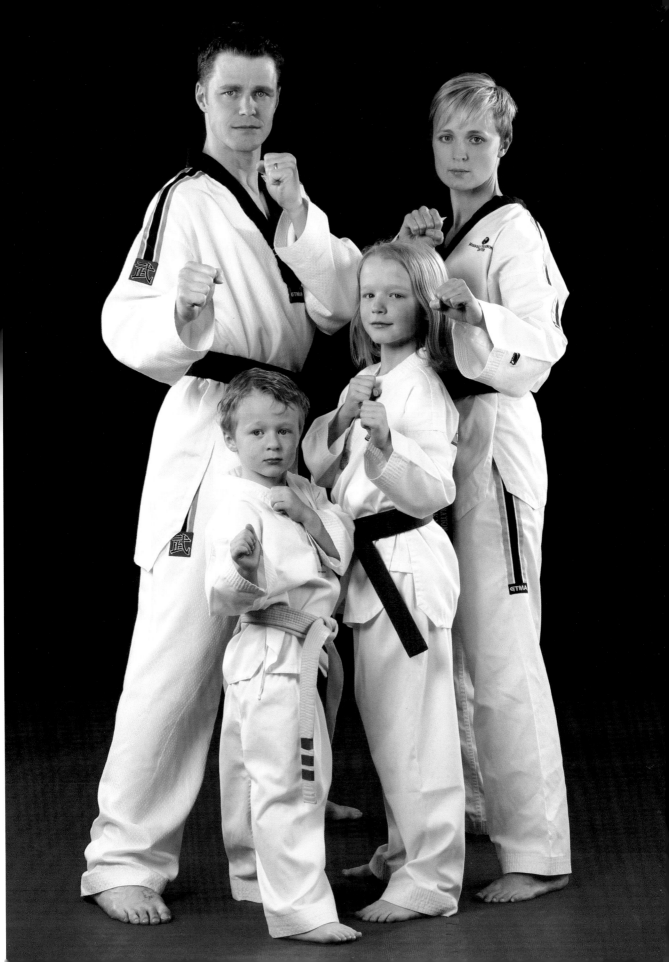

CASE STUDY 36

Cormick and Kincaid

ASSIGNMENT

A client hired me to photograph her two sons, Cormick and Kincaid. I had met them through play dates with my children and knew they were spirited young fellows. They would be fun to photograph—if I could catch them.

LIGHTING AND POSING

When photographing children, it's best to set up a general lighting plan that allows them to move around. Otherwise you will miss the shot. I started by putting up a mottled, fiery-colored cloth backdrop. Then I placed a large softbox to the right of the camera as a fill light (set at f/5.6) and a medium softbox to camera left as the main light (set at f/8).

I also set up a hair light on a boom stand and placed a piece of full CTO (tungsten conversion) gel over it for a warmer glow. In addition, I put a 1-stop spun glass cloth over the light to bring down the power to f/11. A piece of black wrap was taped to the front of the reflector to prevent any lens flare.

The light was broad enough that Cormick and Kincaid could move around a lot and still remain within the right exposure range—and they did move a whole lot! When I asked them what they liked to do, their response was yoga. So I had them do some of their yoga positions to settle down a little—it was a nice try. Then I asked them to sit on the floor where they decided it would be fun to wrestle. During this match, I kept shooting and saw an opportunity when they had their bodies wrapped around each other. I interrupted them by exclaiming, "Mick! Look at the elephant behind me!" When they both looked at me, I snapped the shot. A moment later, they were back into their own thing.

PHOTOGRAPHING CHILDREN

I started out my career as an AP photographer shooting professional basketball and hockey. I truly believe that experience helped me photograph children. You have to have patience and anticipate the shot. I am constantly looking through my viewfinder, watching what unfolds, and staying ready to press the shutter when the right moment happens.

In some ways, children are actually more difficult to photograph than a sporting event because kids are so unpredictable. To increase your odds, you need to direct them—or at least try to put them in the right spot. Another thing that helps a lot is to politely ask the parents to leave. It's amazing how much more cooperative many kids are when their parents are gone.

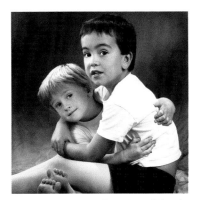

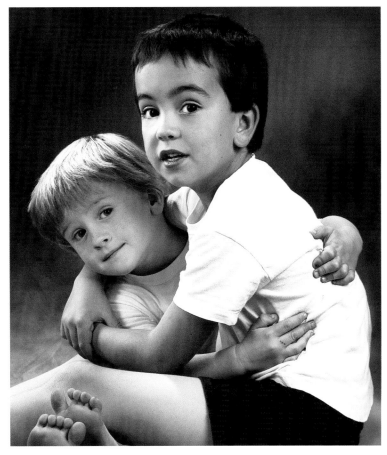

Original image (above) and final image (right).

CAMERA DATA

Camera: Canon 40D
Aperture: f/8
Lens: EF 24–105mm at 55mm
Shutter speed: $^1/_{125}$ second
ISO: 100

POSTPRODUCTION

I imported the images into Lightroom and made my picks. Then, I flagged the selected images and assigned them metadata and keywords (children, siblings, Cormick, Kincaid, playful, etc.). Finally I exported the images to be burned to DVD.

When the lighting is good and the subjects are young, there are usually few changes to be made in Photoshop. Two things did, however, catch my eye that I felt would improve the photo and would not take too long.

The first item that bothered me was Kincaid's pulled-up t-shirt. After duplicating the background layer, I selected the bottom part of the white t-shirt using the quick selection tool. I then selected Edit>Transform>Warp and pulled down on the lower right point until it covered his skin.

The second item was the backdrop. Wrinkled backdrops are one of my pet peeves. There is nothing that makes me cringe more than seeing a beautifully lit portrait with a wrinkly back-

drop! I always try to steam my cloth backdrops and to throw the background out of focus by using a shallow depth of field and placing my subjects away from the backdrop. I did all those things in this image, but when Cormick and Kincaid were playing on the backdrop they managed to mess it up a bit. In truth, it was worth it to me, though—I would never have wanted to stop them from having fun just so I could straighten the backdrop.

Pulling down the hem of the t-shirt.

To fix the problem, I selected the backdrop with the quick selection tool. Then, I went to Select>Modify>Contract and set it to 4 pixels, contracting the selection to get a cleaner blur. Finally, I went to Filter>Blur>Lens Blur, set the radius to 87, and hit OK.

Everything else looked good, so I flattened the layers and saved the image as a TIFF, a high-quality JPEG, and as a JPEG for my web site.

Contracting the selection.

Applying the lens blur filter.

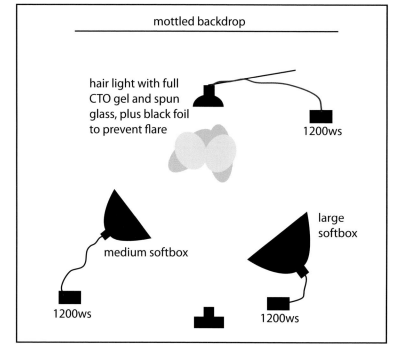

Hat Catalog: Studio

SHOOTING ON WHITE

Shooting on white is the preferred way to do a commercial shoot in the studio. To do it well, follow two simple rules. First, make sure the background is around 1 stop brighter than the main light. Second, watch for flare, which is caused by the subject being too close to the background or back lights kicking light directly into your lens. If you see flare, move your subject away from the background, gobo your backlights, and use a lens shade.

CAMERA DATA

Camera: Canon 40D
Aperture: f/14
Lens: EF 24–105mm at 105mm
Shutter speed: $^1/_{30}$ second
ISO: 100

ASSIGNMENT

At a party, I met a husband and wife team who own Everest Design, a company that imports hats from Nepal. After I told them about my work, the husband mentioned they had just finished a catalog but would be interested in hiring me for the next one. I had just moved into my studio and was excited to utilize it. His company coordinated the models, hair, and makeup.

LIGHTING AND POSING

Showcasing the hats was paramount for this shoot. It was also important to create a general lighting setup (since the models would be moving around), to produce a clean design (since the client wanted to add type or backgrounds to the images), and to show the texture of the hand-knit products.

I started off by setting up a beauty dish as the main light. I powered it to f/14. I then placed a 1x6-foot softbox to camera right for fill; I powered this light to f/11. I set up a white paper background and placed strobes on either side of it, pointed directly at the background. I taped black foil to the inside edges of the reflectors to block the light from flaring onto the subjects. I powered the background lights to f/16.

If you haven't noticed, the human model for this shot is Dakota, Ms. Teen Montana. When the client was looking for models, I suggested Dakota, and it turned out to be a win–win. The other subject is my dog Patch, who is good at following my commands. I asked Dakota to kneel and wrap herself around Patch, then look at the camera. When I said "Patch!" she obediently turned her head to me. No treats, no animal handler—just pure alpha-male energy. It was almost too easy!

POSTPRODUCTION

During the session I had my assistant download the images into Lightroom, while I continued to shoot. She also applied the

metadata and assigned keywords. When she was finished with each card, she exported the images onto a DVD. This allowed me to continue to shoot and format the cards, knowing the images were safely archived in two different places. After the shoot, I selected the final images and burned them onto a DVD. I then created a web gallery and assigned a URL to send to the client.

The image I chose really didn't *require* any postproduction, but I imported it into Photoshop to take a closer look. After duplicating the background layer and tweaking the levels, I zoomed in and did notice some blemishes on her chin. I removed these with the spot healing brush (with the content aware setting active). I used the same tool to remove her nose piercing and a few stray hairs. I also felt that the hat could look more crisp, so I used the quick selection tool to select it, then applied the smart sharpen filter (amount: 94; radius: 3.4; "more accurate" box checked).

For fun, I decided to drop a winter scene image into the background. I used the quick selection tool to select the model from the image and drop her into the winter scene image. I then used the Edit>Transform>Scale command to scale her appropriately.

I felt she looked a bit too cold (in terms of the color temperature) so I went to Image>Adjustments>Photo Filters and applied the warming filter (85) with the density set to 18 percent and the "preserve luminosity" box checked.

The background seemed too sharp, so I went to Filter>Blur>Lens Blur to soften it. To cool down the background, I went to Image>Adjustments>Photo Filter and chose the cooling filter (80). I applied this using a density setting of 39 percent. I also checked the "preserve luminosity" box.

Applying the smart sharpen filter.

Original image (left) and the edited version (right).

Applying the photo filters in Photoshop.

Once everything looked good to me, I flattened the image and saved it as a TIFF, a high-resolution JPEG, and a JPEG for on-line viewing.

Original image (above) and final image (right).

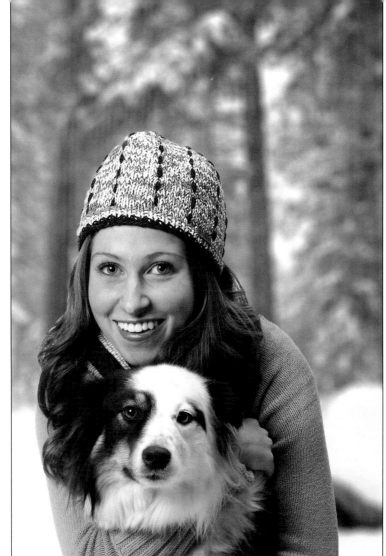

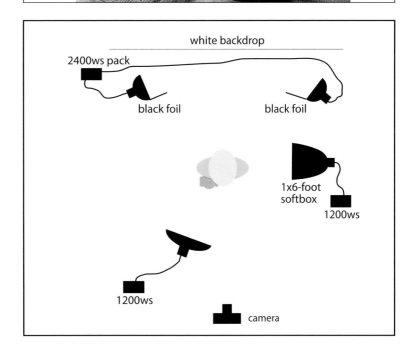

CASE STUDY 38

Hat Catalog: Outdoors

ASSIGNMENT

This portrait is another I created for Everest Design. Unlike the session in the previous case study, all the images for this catalog were shot on location—in the dead of winter with temperatures hovering around 20 degrees. We were hoping for snow—and the night before the shoot we got about a foot. (Can you imagine the costs of creating that look in sunny Los Angeles?) The client found all the models and came to my studio to sort through the shot list and brainstorm location ideas. After shooting most of the images next door at a coffee shop, we decided to brave the icy temperatures and head outside.

LIGHTING AND POSING

Knowing we would be outside in freezing temperatures I chose to go with small lights: a Canon 580EX II and a Canon 550EX (plus lots of extra AA batteries). The beauty of the new speedlights (by Canon, Nikon, and others) is that you can easily use a main (master) flash to trigger one or more additional (slave) flashes. In this case, I wanted the master flash to be about half a stop less than the backlight, so I set it to -1 and placed it on the camera's hotshoe with a Gary Fong diffuser attached. I set up the other flash as a slave. I pumped it up to half a stop higher than the ambient light to create strong backlighting. (And, yes, I did this all *inside* before we marched out into the cold!)

As we walked around the neighborhood, I shot while my assistant pointed the flash at the back or side of the model's head. When we got to a nearby bridge, I looked out across the icy water and decided that this was good place to stop and shoot a series. I had my assistant direct the slave flash at the far side of the model's face. I set my camera to the program mode and let the camera and flashes do all the thinking at first. However, I soon decided that the ambient light was too light, so I switched to the shutter priority (Tv) mode and set my shutter

A LOT WITH A LITTLE

This is great example of how you can do a lot with a little. In the previous case study, I set up a shot with all kinds of expensive lighting equipment and Photoshop wizardry. This image was made with just three light sources: two speedlights and the cold sky, proving that great images aren't all about having a big budget.

CAMERA DATA

Camera: Canon 40D
Aperture: f/4
Lens: EF 24–105mm at 105mm
Shutter speed: $^1/_{30}$ second
ISO: 100

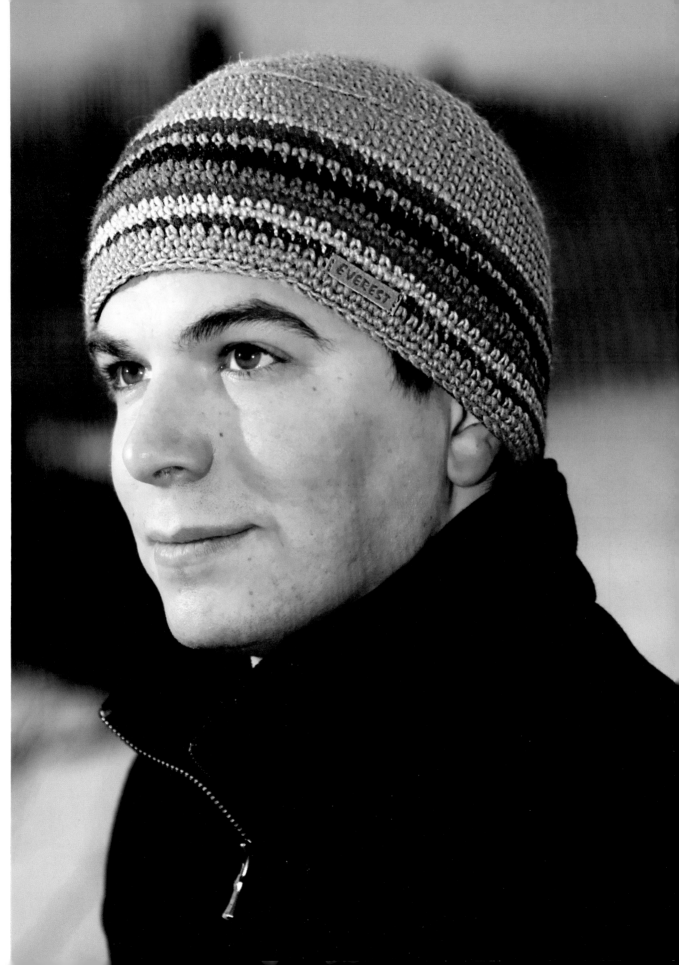

images, this will look familiar. By sliding the yellows and greens to the left I was able to evenly darken the background to bring out the subjects. Sliding the reds, blues, and magentas to the right lightened their skin tones.

My next task was to lighten their eyes (it was an early-morning shoot, after all!) and brighten their teeth. I used the quick selection tool to select the teeth and eyes on both subjects. I used the refine edges command (Select>Refine Edges) to tweak the selection. Once I was satisfied with it, I used the hue/saturation dialog box to desaturate the tones in their eyes and teeth (–43) and increase the lightness of these areas (+32). You can't go too far without the change looking artificial.

I then selected the spot healing brush to get rid of a few stray hairs. To remove the dark circles under their eyes, I selected the dodge tool and set it to shadows at 50 percent. I also

Before and after applying the surface blur filter.

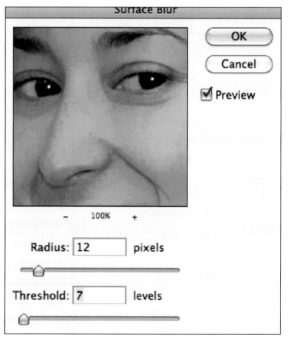

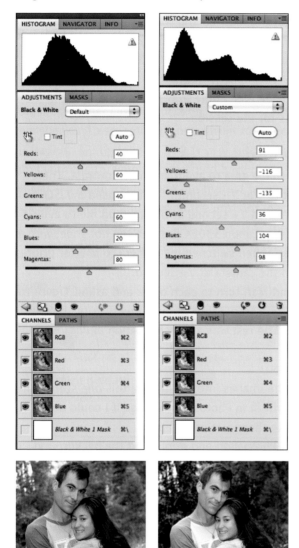

Adjusting the color sliders on the black & white adjustment layer.

on-camera flash
with Gary Fong
diffuser

wanted to soften their faces slightly, which I did using the sur-
face blur filter (radius: 12; threshold: 7).

The last item on my list was removing the Pepsi logo from
the t-shirt. I used the polygonal lasso tool to select the Pepsi
logo, then eliminated it using the clone stamp tool.

It looked good to me, so I flattened the image and sent
the file to Canvas on Demand, who shipped the final artwork
directly to Trevor and Mari in Los Angeles. (When I visited them,
I saw that they did a beautiful job framing the canvas print and
hung it in their guest room—a high compliment!)

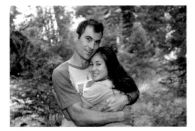

Before (above) and after (right).

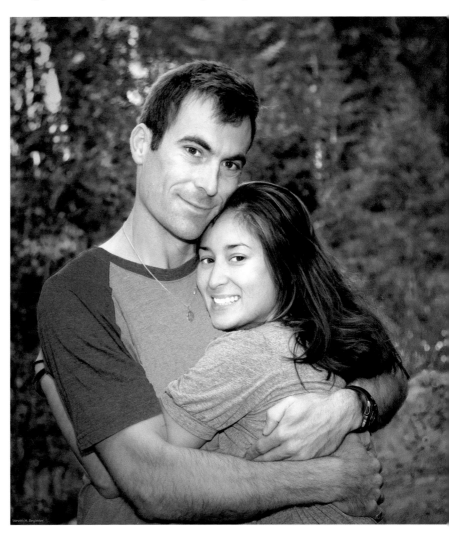

Parks and Recreation

ASSIGNMENT

I was hired to photograph some children for a billboard to promote the Parks and Recreation Department of Missoula. The idea was to create a fun, quirky image to get the attention of the community and let them know about all the fun stuff available for kids.

LIGHTING AND POSING

The art director sent me a sketch of the layout, showing three children dressed in different activity gear with fun gestures. The client wanted the children photographed on white in order to drop in a colorful background for the ad.

For the session, I put up a 12x30-foot white cloth backdrop and placed a piece of white Formica on the floor for the children to stand on. A solid white surface makes it easier for the models to move around and facilitates knocking out the background in postproduction.

I then set up my main light, a large softbox, to evenly illuminate the three children at f/14. To make it look like the children were outdoors, I set up a beauty dish for the hair light, powering it to f/18 for strong backlighting (as if from the sun). I then set up a 1x6-foot softbox at f/18 for accent light on the models.

I knew that I would need to set my background lights to f/22 to create a bright white. I set up shoot-through umbrellas on each side of the background to spread the light evenly. To avoid light spilling onto my models I taped black wrap onto the reflectors.

The models arrived with an assortment of colorful clothing to choose from. Once we decided on the wardrobe we were ready to go.

We started by shooting the kids much as they were posed in the sample layout—straight on. Once those shots were "in the can," the art director asked if we could distort them more. To do this, I switched to my Canon 10–22mm zoom lens. This is not a typical portrait lens, but it worked for an image where we wanted the look to be silly and fun.

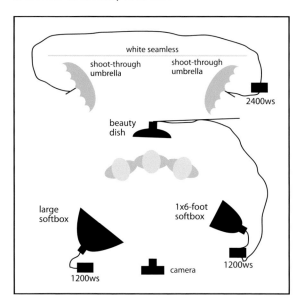

CAMERA DATA

Camera: Canon 7D
Aperture: f/14
Lens: EFS 10–22mm at 10mm
Shutter speed: $1/100$ second
ISO: 100

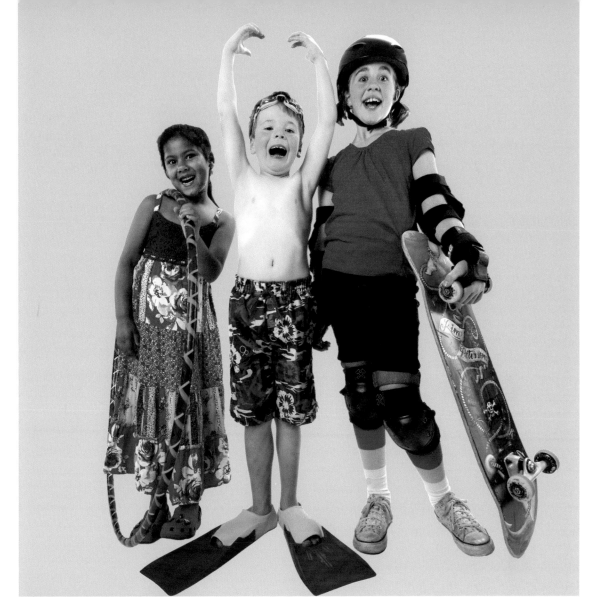

Original capture (above) and final image (top).

I had the children scream "ice cream" as loud as they could on the count of three, and asked the boy in the middle to lift his arms up when he screamed. I shot these images from different angles, low and high. Ultimately, though, I decided (since this would be a billboard) to have the kids looking down—as if seeing the traffic going by. The art director and I agreed that we had the shot after this series.

POSTPRODUCTION

After the chaotic shoot, the art director (Steve Robertson) and I retreated to my quiet office, downloaded the images to Lightroom, and selected three potential winners. After making a DVD

backup, I sent the three picks to the designer and Steve so they could determine the final image. Once it was selected, I went to work.

I exported the image into Photoshop and duplicated the background layer. My first step was to crop the image and lose the rest of the studio. To begin knocking out the background, I used the quick selection tool. When I was satisfied with the result, I saved the selection. Using the levels, I then contracted the histogram and sent the shot off to the designer, Laura Blaker, to do her thing.

Saving the selection.

When further tweaking the image for this book, I decided that the hula-hoop was blended into my daughter Metika's dress and was hard to read. To address this, I selected the hoop with the quick selection tool and went to Image>Adjustments>Channel Mixer. I moved the red slider to the left to –128, turning the hoop green and making it stand out.

To add a color to the background, I reloaded my saved background selection and used the eyedropper tool to select a color from the boy's swim trunks as the foreground color. I then went to Edit>Fill and chose the foreground color. Poof! The background was turquoise.

Everything looked good to me, so I saved the shot as a TIFF, a high-resolution JPEG, and as a JPEG for on-line viewing.

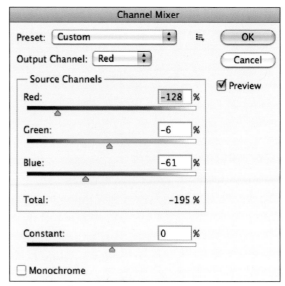

Using the channel mixer.

Using the color picker.

Filling with the foreground color.

HDR (or "Look, Ma—No Lights!")

ASSIGNMENT

My neighbor owns a Tesla Roadster, an all-electric car that goes from 0 to 60mph in 3.7 seconds and gets 245 miles per charge. Only 2,500 exist and they cost around $150,000. I thought this would be a good opportunity to explore HDR—and ride around town in a cool car. To create an HDR photo, you need three bracketed exposures of the same subject. As a result, the technique is more commonly associated with landscape or architectural photography than with portraiture.

LIGHTING AND POSING

To demonstrate the HDR approach, I waited for a sunny day where the wide range of light values would be difficult (or impossible) to record in a single exposure.

We chose to use a mountain and river scene for the background. The site was also on an incline, which gave me some perspective options. I walked around and framed the shot. I then had Glen position the car. Since this was a portrait, not just a pretty car shot, I decided to have Glen look as if were getting into the car.

I placed my camera on a tripod and used a cable release to avoid camera movement. I then told Glen to find a comfortable position and freeze while I took my three exposures. In these exposures, I only changed the shutter speed, not the aperture. Changing the aperture will alter the depth of field and can make it more difficult to align the three images. After

I felt we had the shot, I packed up and we headed back to my studio.

POSTPRODUCTION

You can create HDR images using Photoshop CS5, but I prefer to use HDRsoft's Photomatix Pro. I have found that it gives me more options and control throughout the process. Also, they offer plenty of tutorials on their product.

After dowloading the images into Lightroom, I picked the sequence I liked best and exported the three images as DNG files onto my desktop, placing them in a folder called "HDR Photos." I then opened up Photomatix and clicked "generate HDR image." I simply chose the images and, through digital magic, the program combined them into one image.

PUSHING IT

High dynamic range (HDR) imaging is fun and can be very creative. The practice has been around since the introduction of photography. It is very subjective in terms of how far you want to "push" this technique. My advice is to do whatever looks good to *you*.

CAMERA DATA

Camera: Canon 7D
Aperture: f/11
Lens: EF 24–105mm at 40mm
Shutter speed: $^1/_{50}$, $^1/_{100}$, and $^1/_{200}$ second
ISO: 100

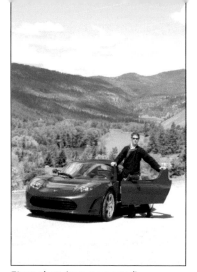

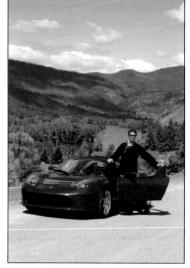

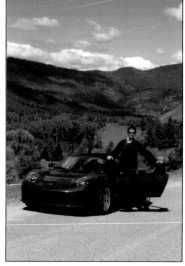

First shot (overexposed)
f/11 at $^1/_{50}$ second

Second shot (correct exposure)
f/11 at $^1/_{100}$ second.

Third shot (underexposed)
f/11 at $^1/_{200}$ second

Generating an
HDR image with
Photomatix.

The unprocessed HDR image will contain too broad a range of tones to be displayed accurately on a monitor. To process it, click "tone mapping" and then make any needed adjustments to the HDR in the dialog box that appears. There are many directions you can go with this. Here, I was just looking to create a normal-looking image with a wide range of detail in the highlights and shadow.

Once I was happy with my changes I saved the image and opened it up in Photoshop to make a few refinements. After duplicating the

Clicking
through to
"tone mapping"
to adjust the
image tones.

Some of the
tone mapping
choices in
Photomatix.

background layer and checking the levels, I used the spot healing brush (set to proximity match and sample all layers) to get rid of the power lines at the top edge of the frame.

I created another layer to blend in the background grass and get rid of dead trees. I did this using the clone stamp tool.

There was a rooftop (near the passenger-side wing mirror) that also distracted from the environment. I isolated it with the quick selection tool, then went to Edit>Fill>Content Aware>Normal>100 percent Opacity. I hit OK and the roof disappeared. I really like this feature.

I also felt the road was too light. If I had a bigger budget, we could have sprayed down the road with water. Instead, I selected the road and used the levels to darken it by sliding the shadows slider (the far-left arrow) to the right.

I liked the color of the river, but there was an area of the water close to the car that was too green and dark. Using the quick selection tool, I selected that part of the water. I then used the eyedropper tool to set the blue part of the water as the foreground color. I went to Edit>Fill>Foreground Color>50 percent to change the color of the water.

The final change was to add a slight sharpening to the entire image. I did this using the smart sharpen filter (amount: 41 percent; radius: 6; remove lens blur; more accurate).

It all looked good to me, so I flattened the image and saved it as a TIFF and high-resolution JPEG. I also converted the image for my web site using the File>Save for Web & Devices command.

CASE STUDY 42

All for a Good Cause

ASSIGNMENT

Artist Jill Meyer asked if I would like to do a promotional poster for the first annual Missoula Breasty Festy, a fundraiser for cancer research and awareness programs. I had just started adding vintage pinup photography to my business and she thought this might be a good way to promote it. I asked her what the concept was. After a brief pause, she replied, "Well, a miniature cow and four or five beautiful women." How could I say no to that?

POSING AND LIGHTING

The day of the shoot, plans changed a little when four of the five women bailed out. Fortunately, the one left standing was Robyn, the former Ms. Montana. We traveled to a ranch where the cow (Clover) was waiting patiently.

It was an overcast day, so I didn't need to worry about the lighting direction. When I found an open field with a mountain view, I set up my light, took some readings, and had Clover and Robyn come to the area.

I had Clover's handler, Jill, place her in the frame. I reasoned that once the Clover was in place, Robyn could take care of herself. At one point, the cow did step on her foot—but she was a good sport and didn't complain.

I knew the poster was going to be a vertical and needed a lot of space for type and art, so I took advantage of the height difference between Robyn and the cow to create that space.

The lighting was pretty straightforward. I set up my Hensel 1200ws pack with a medium softbox. With a Bogen Super Clamp and U brace, I weighted the light stand using my Hensel pack. This prevented it from blowing over (remember, a softbox acts like a sail outdoors). I also placed a large plastic bag underneath the legs. When I place a metal light stand on wet grass, I seem to have problems with the light triggering uncontrollably—it might have to do with electricity, metal, and water.

Original image (above) and final image (facing page).

DIVIDENDS

This was one of those gratis jobs that paid big dividends in an unplanned way. At the ranch, I met Lynn, who managed the horses. She asked me to create original artwork for an event at the ranch— and they ended up buying seven large canvases!

CAMERA DATA

Camera: Canon 7D
Aperture: f/11
Lens: EF 24–105mm at 50mm
Shutter speed: $^1/_{160}$ second
ISO: 100

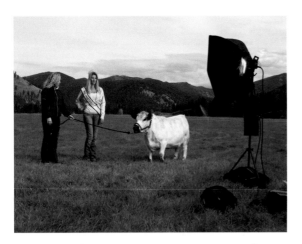

The ambient light reading was f/8 at $^1/_{160}$ second, so I powered up the strobe to illuminate my subjects at f/11 at $^1/_{160}$ second, creating the look of a little sunlight.

POSTPRODUCTION

After backing up and keywording the images, I selected my favorite. There was definitely some postproduction work needed, so I exported it to Photoshop, duplicated the background layer, and checked the levels.

The first item to remove was the rope on Clover. I did this by selecting the rope, then applying Photoshop CS5's content aware fill (Edit>Fill>Content Aware). I also decided to get rid of the sprinklers in the background and the brown spots on the mountain. This was another job for content aware fill. (*Note:* Before Adobe CS5, I would have done these jobs with the clone stamp tool.)

Using content aware fill on selected problem areas.

We only had a red rose, but pink is the color for breast cancer awareness, so I selected the rose with the quick selection tool. Going to Image>Adjustments>Replace Color allowed me to quickly change the color of the rose and bump up its saturation.

The replace color dialog box being used to change the color of the rose from red to pink.

I also wanted to darken the sky to bring out Robyn's crown. After selecting the sky with the quick select tool, I opened the curves, chose the blue channel, and dragged the curve line down to the left to add more blue to the sky. With the sky selection still active, I then used the levels to contract the histogram, darkening the sky.

Next, I selected Robyn's teeth with the quick selection tool and used the hue/saturation dialog box to brighten them.

The final step was to sharpen the overall image using the smart sharpen filter (amount: 22 percent; radius: 1.7; remove lens blur).

When I was satisfied, I flattened the layers, saved the file (as a TIFF, high-resolution JPEG, and JPEG for online viewing), and burned a CD for the client.

Architects and Designers

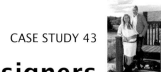

ASSIGNMENT

Studio Beppa, Ltd., a Chicago design/architecture firm, hired me to photograph a project they had recently completed. We scheduled the shoot for a day when some people from the firm were going to fly in to add some finishing touches before their client arrived that evening. Robert, a partner in the firm, also asked if I could photograph him with his partner for their own publicity—at an additional fee, of course.

POSING AND LIGHTING

I photographed Robert and Tina inside while the house was lit it for the interior shoot. The evening light was really nice, though, and Robert also wanted me to incorporate part of the deck, which was an element of their design.

The stairway offered a good way to stagger their heights. Once Tina was in a comfortable pose with her elbow on the railing, I directed Robert to stand behind her, leaning on the stairway rail and placing his left hand in his pants pocket. His bent elbow created a line leading back to Tina, linking the two.

This stairway faced east so I had their backs to the sun. I had my assistant, Christy, set up

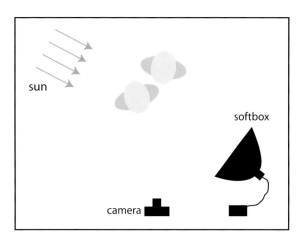

a medium softbox, which she anchored with her body to camera right (since the wind was picking up). The backlight read f/11 at $1/200$ of a second, so I had Christy power up the strobe to illuminate Robert and Tina at f/8 at $1/200$ second. If I'd had another assistant handy (one can dream), I would have had them hold up a large white silk scrim to diffuse the sunlight on the sides of the subjects' faces—but we have to do the best we can with the resources available to us!

POSTPRODUCTION

After importing my images into Lightroom and burning my selections onto a DVD, I created a web gallery for the client.

My final pick needed some retouching, so I exported it to Photoshop, duplicated the background layer, and checked the levels.

The first problem I noted was the post coming out of Robert's head. I used the quick se-

CAMERA DATA

Camera: Canon 7D
Aperture: f/8
Lens: EF 24–105mm at 38mm
Shutter speed: $1/200$ second
ISO: 100

Blending the highlights on the side of Tina's face.

Blending the highlights on the noses.

Softening with the surface blur filter.

lection tool to isolate the area. Then I removed it with the clone stamp tool.

Using the healing brush and clone stamp tools, I next blended away some of the bright highlights that I felt were unflattering on the noses of the subjects. I also softened the right side of Tina's face with the blur tool and the clone stamp tool. To soften the skin overall, I applied the surface blur filter.

At that point, I felt it was time to stop and not overdo the retouching on the subjects. Moving on to the background, I selected the mountain in the background and used the clone stamp tool to make it more "grassy" looking. I then selected the lamp that was peeking out between the back posts and applied the content aware fill to remove it.

I darkened the rock next to the light by selecting it with the quick selection tool, opening the curves, and pulling down the right side of the line. I also decided that I needed to darken the sky and increase the saturation of the yellow flowers. Both changes were made using the replace color function (Image>Adjustments> Replace Color).

QUICKSAND

This image is a good example of why I try to get it all done at the time of the shoot. If I'd had another assistant to hold a scrim to reduce the highlights on their faces it would have saved me a lot of time in postproduction. Photoshop is a great tool, but you should avoid wasting endless hours in what I call the quicksand of photo retouching. It's important to step back from the photo and know when to stop. It's also important to think about the most efficient way to make the changes that *are* needed. If you have the budget, you can also outsource the postproduction, giving you more time to spend behind the camera.

My next step was to straighten out the foreground post that Tina was leaning on. I used the Cmd+' keyboard shortcut to bring up the grid as a reference. I then went to Edit>Transform>Skew. Grabbing the upper left anchor, I moved it to the right until the post lined up with the grid.

My final step was to sharpen the overall image with the unsharp mask filter (amount: 24 percent; radius: 1.8).

After a final look, I felt the image was the way I wanted it to look, so I flattened the file and saved it as a TIFF and a high-resolution JPEG. I also converted the image for my web site using the File>Save for Web & Devices command.

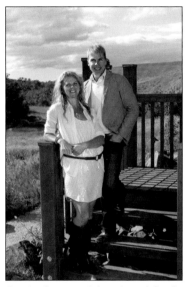

Original image (above) and final image (right).

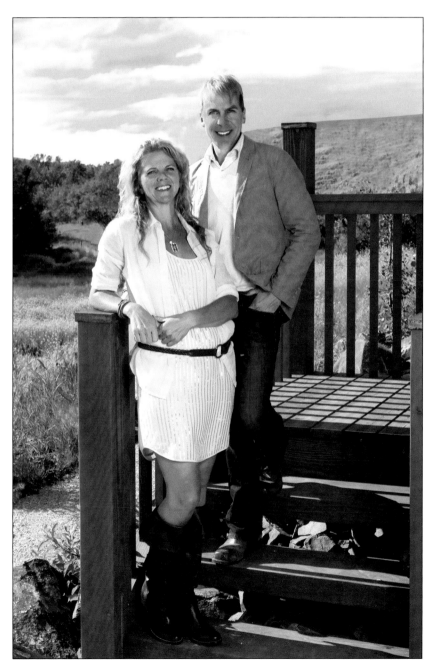

CASE STUDY 44

Continuous Light

ASSIGNMENT

Ever since the DSLR went hybrid, as both a still-
and video-capture device, I wondered what
lights would be developed to allow shooting
both in one session. Strobe doesn't work for
video, and tungsten is tough to balance with
daylight. HMI lights are great but very expen-
sive. I decided to look into what Gary Regester,
creator of the Plume softbox, was up to and
read about his innovation called the Scandle.
Distributed by Lowel, this is a daylight-
balanced fluorescent fixture with a clustered
arrangement of lamps and universal speed ring
for the easy attachment of modifiers.

I contacted Gary and asked for a loaner.
Three days later I had Scandle in my studio.
I wanted to test the light in an interesting
environment that would show off the daylight
color balance. I also wanted to see how well it
performed on skin tones. I called Red Bird, a
local restaurant (two thumbs up, by the way!),
to arrange a session in their wine bar. Then I
called my business partner Tawnie to set up
the shoot.

LIGHTING AND POSING

For a harder look, I decided to use the Scan-
dle's collapsible aluminum cone reflector
rather than a softbox. I set up the light behind
the bar, directed at Tawnie, and plugged it in.
It has a switch on the back of the head that
controls each tube, making it simple to reduce
or increase the light output.

Shooting at ISO 400 from a tripod, I set my
camera to f/2.8 for a shallow depth of field. In
program mode, my in-camera meter measured
$1/30$ second at f/2.8. Perfect.

While Tawnie was waiting for me to set up,
she was on her smart phone texting, so I shot
some of those frames. I also had her pose sip-
ping some of the sparkling wine, looking at a
mirror in a compact, and glancing away as if
waiting for someone. After looking through all
the images, I was drawn to the first few shots
of her on the smart phone. At the very end of
the session, I shot a color checker for color

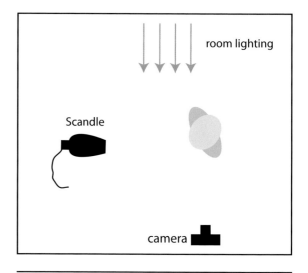

CAMERA DATA

Camera: Canon 7D
Aperture: f/2.8
Lens: EF 24–105mm at 34mm
Shutter speed: $1/30$ second
ISO: 400

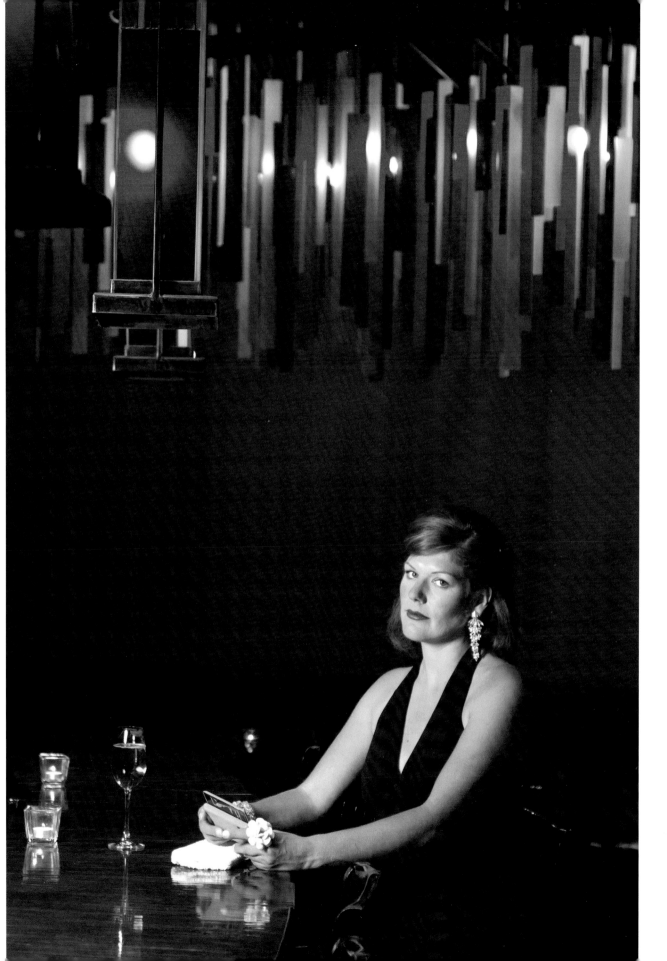

reference. I then turned the camera to the horizontal mode and shot a short video clip. I have to say the light looked great in the video—and what an easy transition!

POSTPRODUCTION

I imported the images into Lightroom, then opened color checker image. In the develop module, applying the white balance pen to the gray swatch on the color checker brought the temperature to 4300K and the tint to +8—not a big shift. I then sharpened the image and applied the noise reduction in Adobe Lightroom 3 (a reason why I was not worried about shooting at ISO 400). I then synched all the selected images to these settings.

Once I decided on the image seen in this case study, I exported the file to Photoshop for a closer look. I checked the levels and I pulled the highlight arrow to the left to brighten up the overall image. I then used the patch tool to remove little highlights on her nose and chin. The final adjustment was to apply the smart sharpen filter.

That was all the postproduction that was needed. I flattened the image and saved the file as a PSD, a TIFF, and a high-resolution JPEG. I also converted the image for my web site using the File>Save for Web & Devices command.

Adjusting the white balance.

Applying sharpening in Lightroom.

A RETURN TO PAST TECHNIQUES

An advance in technology (the addition of HD video capture to DLSRs) has, ironically, caused a resurgence in the use of continuous light sources—the first type of artificial lighting early photographers used. I was pleasantly surprised by the quality and easy of use of the fluorescent Scandle. The one drawback might be the output of power; opening up to f/2.8 at $^1/_{30}$ second may not provide enough depth of field for your needs. It all depends on the image. The other type of continuous lighting you might want to look at is LED. Lowel produces a nice a selection of both A/C and battery-powered models for photographers. For all you wedding photographers thinking about shooting motion at the dance, take a look.

Pinups: The Evolution of a Style

One of the advantages of digital photography is the ability to create different styles in postproduction. For me, this revelation became apparent when I decided to explore a niche of photography known as pinup photography (derived from the common practice of men pinning up calendars containing photos of seductively dressed women). Although pinup-style photography has been around since the early 1920s, it had its heyday in the '40s and '50s.

To prepare for my first test shoot, I researched the different genres of pinup photography, I found a plethora of information on a wide range of styles—cheesecake, zombie, alt, burlesque, modern retro, psychobilly, rockabilly, rockachola, swimsuit, tiki and more. The more I researched the topic, the more I realized the potential market—and the challenge of creating my own style of pinup photography.

For me, however, this type of photography seemed like a good fit. I love lighting, love to photograph women, enjoy creating fantasy images, and like learning new techniques in postproduction. As expected, I have met many challenges (and had plenty of disappointments) along the way—but when a pinup shoot is booked, I really look forward to the session and creating what I hope to be the next iconic pinup.

I hope this body of work will inspire you and push you to start thinking about creating your own signature style.

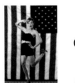

CASE STUDY 45

A True Patriot

ASSIGNMENT

Lee, a fan of Betty Page and the pinup genre, came to the studio with several wardrobe changes and prepared to do her own hair and makeup. We matched some scenarios to the wardrobe—and about an hour later, she came out of the dressing room looking the part.

LIGHTING AND POSING

For this shot, I set up white seamless and placed the half-inch white Plexiglas on the floor to support the model in her high heels and create a clean line for clipping in postproduction.

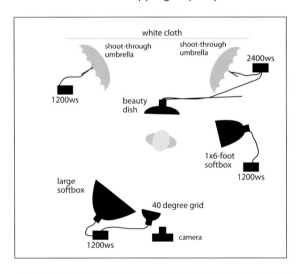

CAMERA DATA

Camera: Canon 7D
Aperture: f/9
Lens: EF 24–105mm at 45mm
Shutter speed: $^1/_{125}$ second
ISO: 100

I set up my main light on a boom stand and placed a 40-degree grid on the reflector. I raised it high enough to create a butterfly shadow under Lee's nose. (When Lee got on to the set, I adjusted it to her height.) The main light was powered to f/9. For fill, I added a large softbox (at f/8.5) behind the main light. To create skim light, I set up a 1x6-foot softbox (at f/11) behind the subject to camera right and directed toward the main light. The final lights were on the background. I set up one light on each side of the background and directed them toward the middle of it. I placed a shoot-through umbrella on each head and taped black foil on the camera-side edge each reflector to block light from the subject. I powered these to f/14 to light the background evenly from side to side.

Here, I decided to do a twist on the military pinup, in which the model wears some sort of uniform. I had Lee salute the camera with her right hand and place her left hand on her hip for symmetry. For that corny "whoops!" look seen in many pinups, she kicked up her heel. We did this many times until I got the shot.

POSTPRODUCTION

After importing the images into Lightroom and making my picks (archived to DVD), I ended up with four strong images for my web site, studio promotion, and portfolio.

I exported the salute image to Photoshop CS5, duplicated the background layer, and

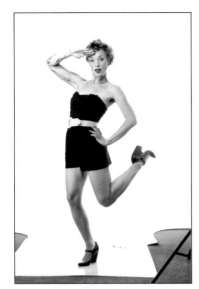

Original image (above) and final image (right).

Refining the edge of the selection for the clipping mask.

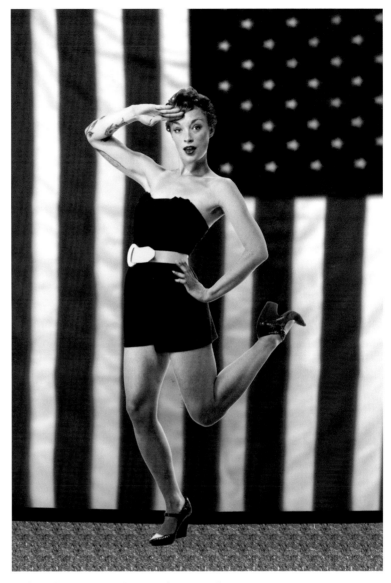

checked the levels. Knowing I wanted to drop in a different background, I decided to create a clipping mask. I started by selecting the white background with the magic wand tool (tolerance: 32). I held down the shift key to add to the selection with each click until most of the negative space was selected. Then I fine-tuned my selection with the quick selection tool, selecting the dark (non-subject) areas.

In Photoshop CS5, I used the refine edges command (Cmd+Opt+R on Mac; Ctrl+Alt+R on PC) to make my selection more precise. I selected the black mask view and used the edge detection option, activating the smart radius function and moving the slider to the right. For further refinement, I used the radius refinement tool to extend the selection of her hair. When it looked good, I used the box at the lower right corner of the dialog box to output the selection as a layer mask. Amazing!

Next, I copied and pasted Lee into a new image (with a transparent background) that

The shot used for the background (left) and the image in place behind Lee (above).

Adding a floor.

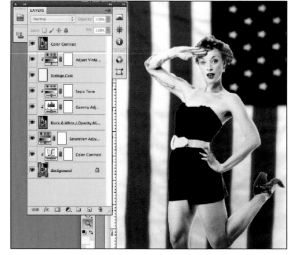

A complex project like this results in many layers.

was the same size and bit depth as the original image and had a transparent background. I brought up the original Lee image that was still selected and copied and pasted Lee into the new image.

I had taken a photo of a large flag with the same lighting as the pinup shot and wanted to use this as my background—but notice my assistant Christy's feet in the shot. In Photoshop, I used the quick selection tool to select just the flag, then copied and pasted it into the Lee image, placing it on the layer below the model so it fell behind her. With the flag layer selected, I went to Edit>Transform>Scale to enlarge the flag until it looked right to me. I then used the Gaussian blur filter to throw it out of focus. I still felt the flag looked too bright, though, so I used the levels to darken it.

To give Lee a floor, I left the bottom of the image transparent to add a surface. I selected the transparent portion with the quick selection tool, then used the bucket tool to fill it with a pattern. To add the trim, I selected the polygonal lasso tool and outlined the trim, then painted it black with the brush tool.

In Photoshop, there are many ways to get a vintage look. However, I prefer to use an action

(Mike Warren Vintage Pinup Toner with Illustration) that was created by MikeW Photoshop Actions (to order, contact: mike@mikedubu. com). I usually still tweak the image after the transformation, but I find it to be very helpful and a real time-saver.

As you can see in the screen shot above, there are many layers involved in creating a final image as a digital composite.

BACKGROUNDS

Since I started exploring Photoshop, I find myself shooting textures, out-of-focus landscapes, and generic objects to use as image elements. I have a folder on my desktop and in Lightroom containing these shots. Learning to use the Photoshop filters, transformations, and adjustments will allow you almost unlimited options for creating personalized backgrounds.

Vintage Designer

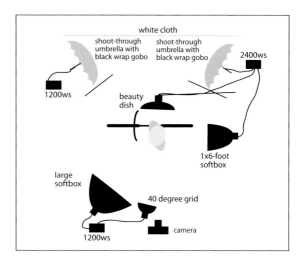

ASSIGNMENT

In my search for models, I learned about a designer who created vintage-inspired clothing. I called Nicole Katherine, simply hoping to purchase some wardrobe items. But when she arrived for our meeting, she looked as if she had stepped out of a 1950s diner (I'm told this is how she always dresses)! I immediately knew I also wanted to use her as a model, and she agreed to do a session.

LIGHTING AND POSING

After my first few pinup sessions, I realized I needed a larger white backdrop, so I invested in a 12x30-foot cloth. I set it up with white Plexiglas on the floor. From my early sessions, I also learned that opening up the lighting and making it less directional would simplify the postproduction process.

I first set up my main light on a boom stand with a 40-degree grid (at f/11) to create butterfly lighting. I added a large softbox on the same side of subject as the main light and powered it to f/11 (notice the fill and main are at the same f-stop). I then set up a 1x6-foot softbox to the left of the model to illuminate the back fender of the bicycle and create an accent light on Nicole's back. I powered up the accent light to f/16. A hair light is, in my opinion, essential in pinup photography. For this shot, I set up a strobe head with a beauty dish reflector on a boom stand and directed it down on Nicole's hair, setting the power to f/16. I directed two strobe lights in shoot-through umbrellas toward the background. I taped black foil to the camera side of the reflectors to prevent light spill on Nicole. The background lights were powered to f/16.

DESIGNERS

Designers are a great resource. Although Nicole Katherine never hired me to shoot her fashions (her primary base is Los Angeles), I learned a lot from her. She gave me ideas about poses, wardrobe, and music—and taught me a bit more about the pinup culture. After this shoot, I felt more confident and had a lot of new ideas for future pinup sessions.

CAMERA DATA

Camera: Canon 7D
Aperture: f/9
Lens: EF 24–105mm at 55mm
Shutter speed: $1/125$ second
ISO: 100

Nicole was natural at posing in the vintage style. The pink bicycle I brought in for the shoot helped create the story. The idea was to create what I like to call the "whoops" moment. In this case, it was the wind from a fan blowing up her dress. I had Nicole put her right foot on the pedal, which seem to work best with the dress and the fan. We tried different expressions but I felt her hand on her cheek with a big smile worked the best.

POSTPRODUCTION

It was a very successful shoot with a lot of images to choose from. After I imported the images into Lightroom and made my selections, I archived them to DVD and created a web gallery for Nicole.

I exported this image into Photoshop CS5, duplicated the background layer, and checked the levels. I then applied the surface blur filter (Filter>Blur>Surface Blur), setting the radius to 9 and the threshold to 5. If you find this effect

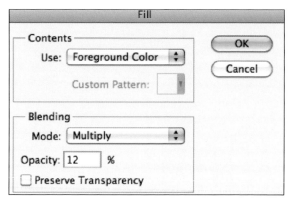

Warming up the background.

is too artificial looking, you can soften it with the smart blur filter (Filter>Blur>Smart Blur). Personally, though, I like the look.

I next whitened the model's teeth and eyes by selecting them using the quick selection tool, then going to Image>Adjustments>Hue/Saturation (saturation: –11, lightness: +11).

To warm up the background, I created a blank layer and picked a warm color from the color checker. I applied it to the new layer by going to Edit>Fill and choosing the foreground color. I set the blending mode to multiply with an opacity of 12 percent.

The last step was adding my logo on the image (it's seen below, but omitted from the final images in this section). I keep all my logos on my desktop in a folder called logos. I went File>Place and navigated to the file to apply it in the lower left corner of this shot.

It all looked good, so I flattened the image and saved it.

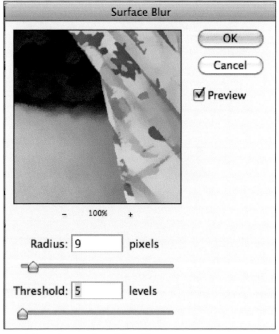

Applying the surface blur filter.

Applying my logo to the image.

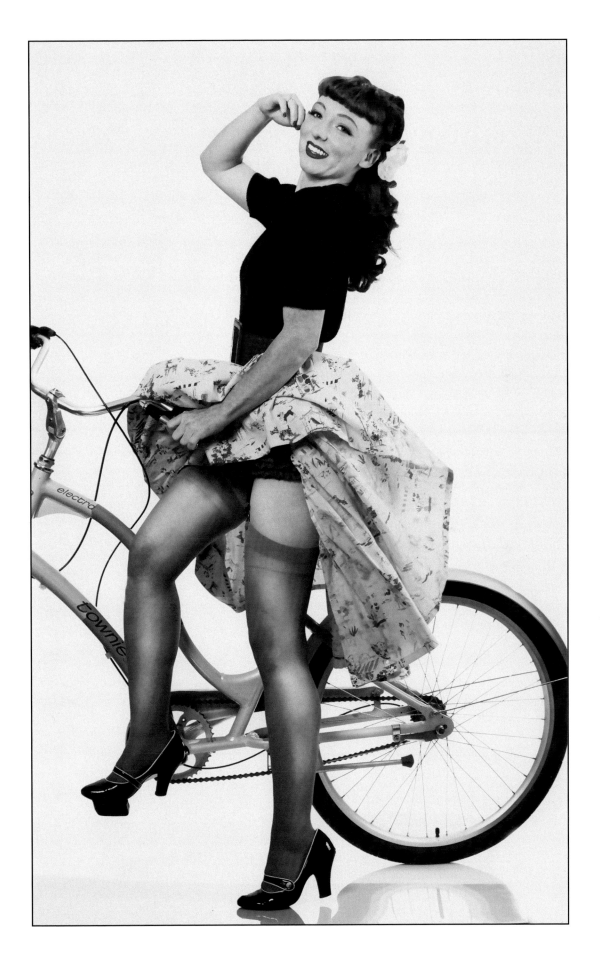

CASE STUDY 47

Brittany with Cocktails

ASSIGNMENT

To get the word out about my new business, I decided to throw a pinup competition in conjunction with a local fundraising event. I used Facebook and a poster to promote the competition. My friend Robyn (former Ms. Montana) helped me with the logistics—where to purchase the sashes and tiara, writing interview questions, finding the judges, and more. It was quite a learning experience. I recruited ten contestants and found three judges for the competition. The winner was Brittany Alan, from Helena. She embodied the Donna Reed style of pinup—wholesome but devilish. Her prize was a pinup photo session from yours truly.

LIGHTING AND POSING

For this image, the main light (at f/10) was set on a boom stand above the fill light. I placed a 40-degree grid on the reflector and raised the main light up until I saw a butterfly shadow under the subject's nose. The fill light, below the main light, was powered to f/8. The hair light, set on a boom stand behind the subject and housing a 40-degree grid spot, was set to f/11. I then placed a 1x6-foot softbox to camera right for an accent light on her dress and legs. The white cloth background was lit with two lights on each side and a gobo was placed on each light to prevent spill.

Since our concept was to create a "Donna Reed" look, I thought it would be fun to have Brittany hold not one but two martini glasses—

something I am sure Ward would approve of. I placed water, acrylic ice cubes, and olives in each glass. To push the message of the two-martini lunch, I had Brittany sip out of one glass and hold the other at the ready. I also had her place her feet with aplomb to counter the thought of too many drinks. Finally, I asked her for a mischievous expression—as if she were getting away with something.

POSTPRODUCTION

As I narrowed down my picks in Lightroom, the martini shot—one of three setups we did

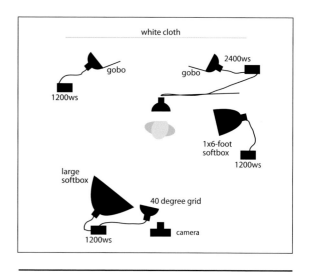

CAMERA DATA

Camera: Canon 7D
Aperture: f/9
Lens: EF 24–105mm at 55mm
Shutter speed: $1/125$ second
ISO: 100

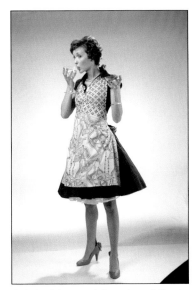

Original image (above) and final image (right).

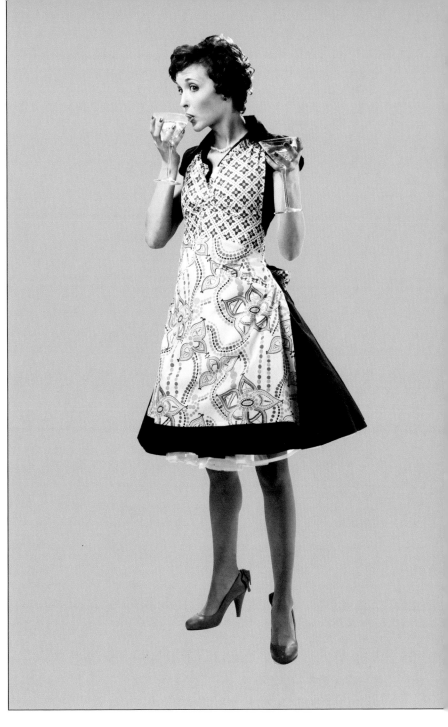

during the session—caught my eye and made me laugh. I thought it would a good image to showcase.

I exported the image into Photoshop, where I duplicated the background layer. I then used the magic wand to select the background, using the lasso tool to fine-tune the selection. Once the background was selected, I applied the curves to whiten it, allowing me to better isolate the model. (There are some great third-party clipping programs and services that will do this for you for a small fee.) I went to Select>Inverse to select the model, then saved the selection for later use. I next duplicated the image and flattened it.

I ran the flattened image through the Mike Warren Vintage Pinup Toner with Illustration Action and began to make my changes. For this particular image, I felt the vintage cast was too yellow. Working on the adjustment layers produced by the action, I reduced the yellow tone and overall saturation. I duplicated the image again and flattened it.

Removing the apron tie.

The next step was to clean things up a little. I didn't like the way the apron tie was sticking out, so I selected it and used the clone stamp tool to make it go away.

To create a background, I selected a color from her dress with the eyedropper tool. I then opened up a new transparent canvas, the same size and resolution as the Brittany shot, and used the bucket tool to fill the canvas with the green color I chose from her dress.

Remember the selection of Brittany I saved a few steps back? Well, this was a good time to use the selection. In the edited Brittany image, I loaded the saved selection, then used it to copy and paste her into the new canvas. I

Erasing to allow the background to show through the martini glass.

Removing the black back on her stockings.

THE SOFT SELL

Creating a cohesive body of work is a great way to get noticed as a professional photographer. Thinking of ways to promote that work, however, is critical to making this approach pay off. I had never put together a pageant before but I thought that being a part of fundraiser, would not only be altruistic, but also bring my pinup work to the attention of a targeted audience. I announced the competition on my Facebook page and my business name was on the event poster, which was distributed throughout the city. Each contestant filled out a form with her contact information and signed a model release. The day of the competition, I had a table at the event, which showed off my work and had a take-away about pinup sessions and pricing. The winner became the spokeswoman for my pinup line—and a great model to work with on other promotions throughout the year. For a small investment of time and money, I received a lot of media exposure—without appearing to sell anything. This "soft sell" method of advertising can be applied to any niche market you're trying to exploit.

moved her around the canvas until I was happy with the placement.

I then zoomed in to fine-tune the image. I noticed that the glass she is holding was lacking the background color. Using the eraser tool set at 27 percent, I brought in the background color by erasing the white on the glass.

The last item I changed was the black heel on her stockings; while it's true to the era, I found it distracting. I selected the area and used the clone stamp tool to remove the black.

I duplicated the final image (maintaining a copy with all the layers), then flattened the duplicate file to save as a TIFF, a high-resolution JPEG, and JPEG for on-line viewing.

Robin and Ursula

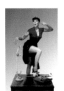

ASSIGNMENT

To promote my pinup business, I held a drawing at my studio. People who stopped in could fill out a form with their contact information, and my daughter drew the winning card from the entries. This a great way to build a customer contact list—and, if you're as lucky as I was, to find a great subject.

The winner was Robin Rose, a talented performer who happened to be into the pinup culture. During our first session, in a burlesque style, she mentioned how smart her pet rat Ursula was. I started visualizing a campy pinup photograph of a secretary on her chair being terrified by a rat. Robin like the idea, so we set up another session.

LIGHTING AND POSING

Here, the lighting was somewhat dictated by the props. Knowing I was going to have the model stand on a chair or desk, I had to place all my lights about four feet higher than normal. The main light was placed on very tall stand with a 40-degree grid pointing down toward my subject's face. It was powered to f/22 (in retrospect, a little overkill). The fill light, placed under the main light, was powered to f/16. A hair light was place on a boom stand behind Robin and set to f/32. The background was a sheet of 10x30-foot white cotton and was illuminated by two heads on each side powered to f/22. That was all the power I could muster—and it's why the background looks

gray in the "before" image (see page 151). It was good enough, though, to silhouette the subject for selection in postproduction.

We started with Robin holding the phone and Ursula doing her own thing. We put some cheese on the typewriter keys to lure her over there. I primarily directed Robin to act terrified (but not *too* terrified) and we shot a lot. During the session, I had an "aha!" moment and decided to place a phone on the table and hang the receiver as if it were falling out of her hand. While Robin and Ursula were taking a break,

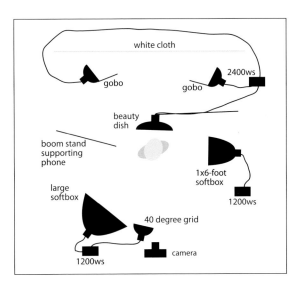

CAMERA DATA

Camera: Canon 7D
Aperture: f/22
Lens: EF 24–105mm at 40mm
Shutter speed: $^1/_{80}$ second
ISO: 100

I set up a boom stand and hung the receiver from some filament. When Robin returned to the set, I had her position her right hand as if she were dropping the receiver and raised the boom stand to place the phone. We put more cheese in the typewriter and started working. At first Ursula was not cooperating—walking all over the table, up Robin's ankle, and even on the phone—but eventually she walked over to the typewriter and started typing (Robin did say rats are smart). I started snapping and got the shot. It was a wrap.

POSTPRODUCTION

Robin and I were so excited to see what we got, so we went right to the postproduction room and downloaded the images into Lightroom. It was a funny session to review, which meant it was a success. There were many images to choose from, but it was the images after the break that seemed to stand out.

After choosing this shot, I exported it to Photoshop and checked the levels. I then used the magic wand tool to select the background, using the lasso tool for fine-tuning. When the background was completely selected, I opened the levels and moved the highlight slider to the left to white out the background. This allowed me to see any areas I might have missed and make sure they were selected. I then went to Select>Inverse to select Robin and saved my selection. I then copied Robin to the clipboard.

The next step was to create a new canvas with the same dimensions and resolution as the Robin image and set the background to transparent. I then pasted Robin's image onto the canvas.

At this point I duplicated the image and applied the Mike Warren Vintage Pinup Toner with Illustration Action. Using the adjustment layers this created, I reduced the opacity slightly. I

Choosing pink for the foreground color.

Brushing pink onto the selected phone.

then duplicated the image to keep a copy of all the layers.

I flattened my working image and began to fine-tune it. The only thing I didn't really like was the color of the phone. I feel like every secretary in the 1950s must have wanted a pink phone. To make it so, I selected the phone with the quick selection tool and finessed the selection with the lasso tool. I then set my foreground color to a shade of pink and brushed on the color at 50 percent opacity.

My final steps created the background. I decide to use the color of one of her blue tattoos,

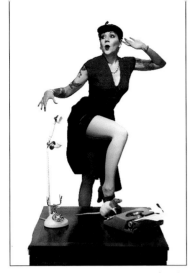

Original image (above) and final image (right).

RATS!

Having never worked with rats before, I relied on the owner to help me wrangle the rat. As with all animals, food seemed to be the answer—along with a lot of patience. It is also important to direct the human while working with the animal talent. You don't want the human to become overly concerned with the animal and forget they are also part of the photo. In a gentle way, tell your subject to disregard the animal and listen to your direction. Finally, be sure to have a lot of extra treats for the animals—it's amazing how fast they will go through them in a session.

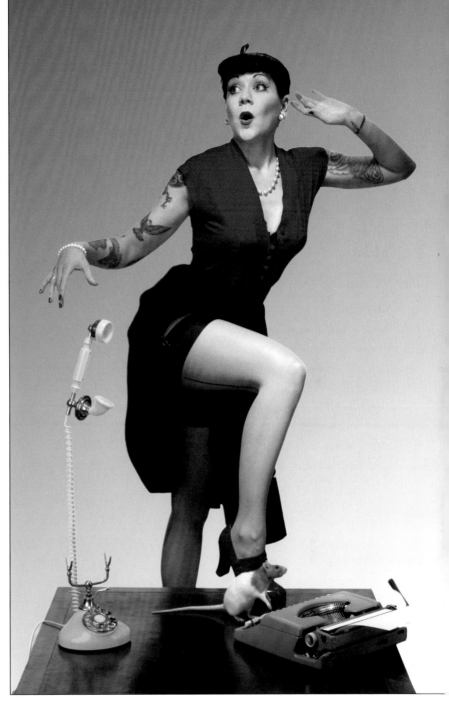

so I used the eyedropper tool to set it as the foreground color. I then created another new canvas with the same dimensions and resolution. Instead of using the paint bucket to drop in the color, I used the gradient tool to create a smooth blend of color (working from the blue I sampled from her tattoo). I then copied the image of Robin onto the background canvas.

It all looked good, so I flattened the image and saved it.

CASE STUDY 49

Cowgirl Lucky Lacey

ASSIGNMENT

Lacey called because her boyfriend, who was soon to be deployed to Afghanistan, was about to celebrate a birthday. She originally asked if I could take a photo of her holding a birthday sign—but I mentioned the idea of doing a vintage pinup and directed her to my website. After she looked at the work, she e-mailed to schedule a pinup session.

LIGHTING AND POSING

Lacey's portrait uses what has come to be my standard lighting setup for pinup sessions (with minor adjustments for each person, of course). I place the main light (at f/16) on a boom stand with a 40-degree grid and create the butterfly shadow under the model's nose. I then set up a large softbox (at f/22) below the

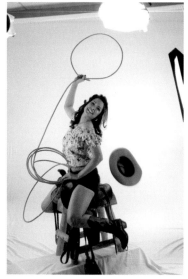

Original image (above) and final image (facing page).

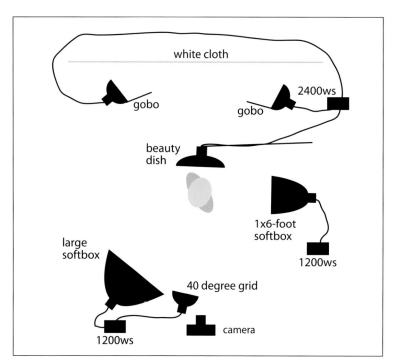

CAMERA DATA

Camera: Canon 7D
Aperture: f/16
Lens: 24–70mm at 38mm
Shutter speed: $^1/_{100}$ second
ISO: 100

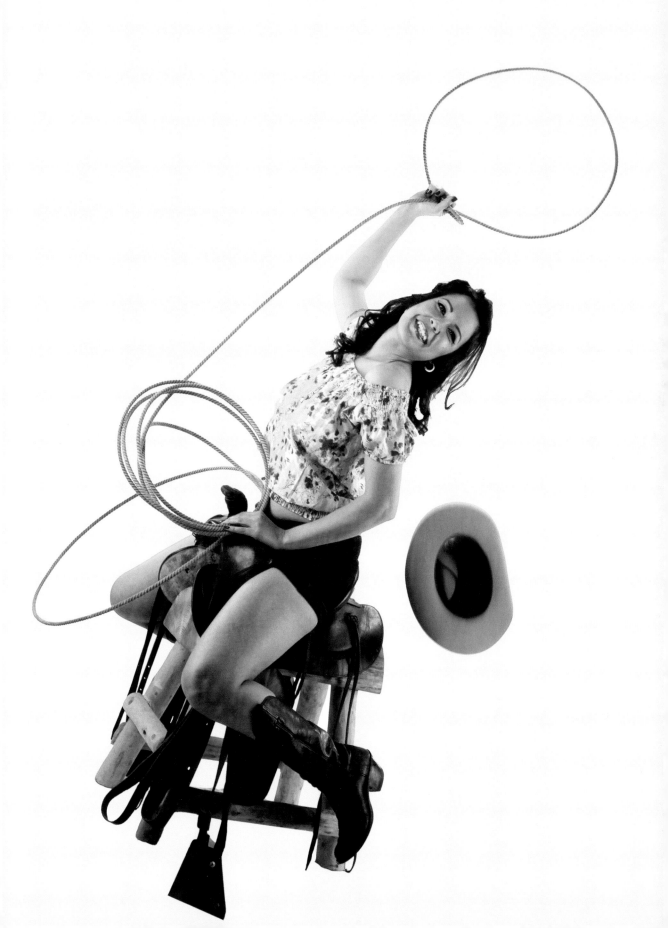

main light and to the left of the boom stand. I add a 1x6-foot softbox (at f/22) a little behind the model to camera right. My background is white cloth illuminated by two strobes on either side powered to f/22.5. The hair light is a beauty dish (with diffusion material and powered at f/22) on a boom stand.

The day before this shoot, I picked up the saddle, lasso, and stand from friend who worked on a local ranch. The saddle stand was too short for the model so I set up an apple box and placed the white backdrop on top. I envisioned a cowgirl yelling "Yahoo!" and twirling her lasso—but Lacey's hat kept falling off when she threw her head back and the lasso started coming undone! Ultimately, I felt the mishap added the "whoops" look that's typical of so many pinups.

POSTPRODUCTION

Ultimately, I liked the surprise element of the hat falling off, so I exported the selected image into Photoshop CS5, duplicated the background layer and checked the levels

With the magic wand tool, I selected the background and inversed the selection so Lacey was picked. I then saved the selection and copied Lacey to the clipboard.

Next, I created a new file (with a transparent background) of the same size as the original Lacey image and pasted Lacey into it.

My first change was to rotate Lacey (Edit>Transform>Rotate) so she looked like she was tipping backwards.

Zooming in, I noticed that some of the selection had cut too far into the shirt sleeve. I used the lasso tool to select the area, then filled it in with the clone stamp tool. I also cleaned up her hair with the eraser tool. Additionally, I lightly sharpened the image with the smart sharpen filter.

Isolating the subject from the background.

I duplicated the image (Image>Duplicate) to prepare for applying the Mike Warren Vintage Pinup Toner with Illustration Action. Once the action was complete, I went through the adjustment layers to tweak the results.

On the background layer, I next selected her teeth with the magic wand tool and brightened them with the Hue/Saturation function. I then flattened the layers to make my final adjustments.

To add the background, I loaded the saved selection and used the eyedropper to choose a background color from her shirt. Once the color was selected, I applied it to the background with the bucket tool at 40 opacity.

When everything looked good, I flattened the image and saved it as a TIFF, a high-resolution JPEG, and a JPEG for on-line viewing.

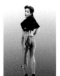

A Mechanic's Dream

ASSIGNMENT

Breanna called me because her boyfriend was off to Alaska and she wanted to surprise him with a pinup photo for his birthday. He was an auto mechanic, so I suggested she bring in his tools and work clothes for the session.

LIGHTING AND POSING

I set up my main light (a 40 degree grid at f/11) on a boom stand to create the butterfly shadow under her nose. I added a large softbox on the same side as the main light and also powered it to f/11. I then set up a 1x6 foot softbox (at f/16) to camera right for an accent light on Breanna's back. For the hair light, I added a beauty dish (at f/16) on a boom stand. I also clamped a zebra reflector to a stand at camera light for added fill on Breanna's face. Two white umbrellas (at f/16) on either side of the set lit the background. I taped black foil on the camera side of the reflectors to prevent light spill onto the model.

Breanna brought a huge socket wrench, her boyfriend's work shirt, and a red bandana. I had her pose with the wrench over her shoulder, leaning on it, and so on—but the pose that caught my eye was when she was just holding it and turned back the camera with her right hand on her hip and arching her back.

POSTPRODUCTION

I downloaded the images, picked my favorites, and burned them onto a DVD as a backup. I then created a web gallery for Breanna to review. There were several images I really liked, but this is one of my favorites. It reminds me of the Bruce Springsteen photo Annie Leibovitz took for one of his album covers.

I exported the image into Photoshop CS5, duplicated the background layer, and checked the levels.

With the magic wand tool, I selected the background. I smoothed the edge of my selection by going to Select>Modify>Smooth and setting it to 4 pixels. I inversed the selection

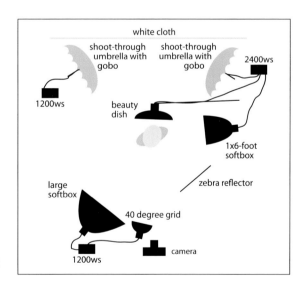

CAMERA DATA

Camera: Canon 7D
Aperture: f/13
Lens: EF 24–105mm at 32mm
Shutter speed: $^1/_{80}$ second
ISO: 100

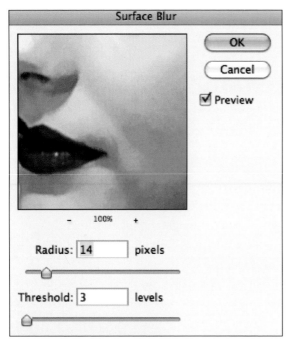

Applying the surface blur filter.

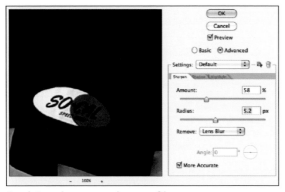

Applying the smart sharpen filter.

tion Action. This created too much yellow in her eyes, so I selected them with the quick selection tool and used the Hue/Saturation command to remove the yellow and brighten the eyes. I also felt the image was a little soft, so I applied the smart sharpen filter.

I decided to apply the surface blur filter for a second time (it was first applied during the action). I felt her skin was still a little too blotchy; pumping up the surface blur seemed to do the trick.

Her shirt was also bulging in the front, so I selected the area and used the clone stamp tool to make it disappear.

At this point, I saved the file and created a new file for the background. For the background color I selected the red of her bandana and applied it using the gradient tool. I copied Breanna from the previous file (using the saved selection), then pasted her into the new document with the gradient background.

The final step was to flatten the layers and save the file as a TIFF, a high-resolution JPEG, and a JPEG for on-line viewing.

The image of Breanna pasted onto a layer overlying the gradient background layer.

(Select>Inverse) so Breanna was selected. Then I copied her image to the clipboard.

The next step was to create a new file the same size as the original with a transparent background. I pasted Breanna's image into this new file. Zooming in, I noticed some blemishes on her legs, which I removed using the patch tool. I also cleaned up a few other minor blemishes with the same tool.

I then duplicated the image and applied the Mike Warren Vintage Pinup Toner with Illustra-

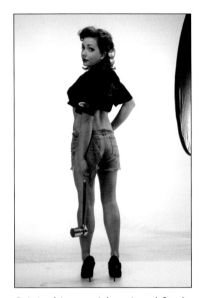

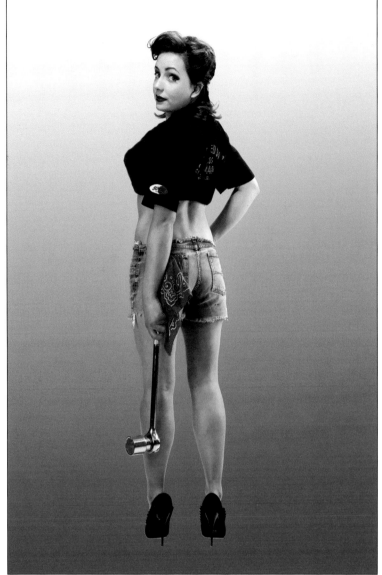

Original image (above) and final image (right).

DIP YOUR TOES IN THE WATER

There are many ways to reach any goal. How far you'll get depends on how much time and money you are willing to spend honing your craft (and remember: in business, time *is* money). My advice is to dip your toes in the water and see how it goes. If you find a need in the marketplace for what you are producing—and a financial reward—then go further and invest in your work and yourself.

I also suggest becoming a member (it's free) of all the LinkedIn photography groups. There are great conversations going on there about the state of professional photography—as well as excellent tips on business, photographic technique, and our field in general.

My goal in writing this book was to introduce to you a comprehensive way creating professional portraiture—from concept to execution. I hope it inspired you and has given you some tools to compete successfully in this very rewarding profession. If you value yourself and your work, others will follow.

Index

OTHER BOOKS FROM

Amherst Media®

The Art of Color Infrared Photography

Steven H. Begleiter

Learn to previsualize the scene and get the results you want. *$29.95 list, 8.5x11, 128p, 80 color photos, order no. 1728.*

The Portrait Book

A GUIDE FOR PHOTOGRAPHERS

Steven H. Begleiter

A guide for getting started in professional portrait photography. Covers every aspect of the field. *$29.95 list, 8.5x11, 128p, 130 color images, index, order no. 1767.*

50 Lighting Setups for Portrait Photographers

Steven H. Begleiter

Unique portraits plus the "recipe" for creating each one. *$34.95 list, 8.5x11, 128p, 150 color images and diagrams, index, order no. 1872.*

Hollywood Lighting

Learn how to use hot lights to create dramatic, timeless Hollywood-style portraits that rival the masterworks of the 1930s and 1940s. *$34.95 list, 7.5x10, 160p, 148 color images, 130 diagrams, index, order no. 1956.*

Studio Lighting Unplugged

Rod and Robin Deutschmann show you how to use versatile, portable small flash to set up a studio and create high-quality studio lighting effects in *any* location. *$34.95 list, 7.5x10, 160p, 300 color images, index, order no. 1954.*

Lighting Essentials

Don Giannatti's subject-centric approach to lighting will teach you how to make confident lighting choices and flawlessly execute images that match your creative vision. *$34.95 list, 8.5x11, 128p, 240 color images, index, order no. 1947.*

The Art of Off-Camera Flash Photography

Lou Jacobs Jr. provides a look at the lighting strategies of ten portrait and commercial lighting pros. *$34.95 list, 8.5x11, 128p, 180 color images, 30 diagrams, index, order no. 2008.*

Flash and Ambient Lighting

FOR DIGITAL WEDDING PHOTOGRAPHY

Mark Chen shows you how to master the use of flash and ambient lighting for outstanding wedding images. *$34.95 list, 8.5x11, 128p, 200 color photos and diagrams, index, order no. 1942.*

MORE PHOTO BOOKS AVAILABLE

Amherst Media®

PO BOX 586
BUFFALO, NY 14226 USA

Individuals: If possible, purchase books from an Amherst Media retailer. To order directly, visit our web site, or call the toll-free number listed below to place your order. All major credit cards are accepted. *Dealers, distributors & colleges:* Write, call, or fax to place orders. For price information, contact Amherst Media or an Amherst Media sales representative. Net 30 days.

(800) 622-3278 or (716) 874-4450
Fax: (716) 874-4508

All prices, publication dates, and specifications are subject to change without notice. Prices are in U.S. dollars. Payment in U.S. funds only.

WWW.AMHERSTMEDIA.COM

FOR A COMPLETE LIST OF BOOKS AND ADDITIONAL INFORMATION